Remembering
MANCHESTER

Remembering MANCHESTER

Towering Titans and Unsung Heroes

JOHN CLAYTON

THE
History
PRESS

Published by The History Press
Charleston, SC 29403
www.historypress.net

Copyright © 2009 by John Clayton
All rights reserved

First published 2009
Second printing 2010

Manufactured in the United States

ISBN 978.1.59629.706.7

Library of Congress Cataloging-in-Publication Data

Clayton, John.
Remembering Manchester : towering titans and unsung heroes / John Clayton.
p. cm.
ISBN 978-1-59629-706-7
1. Manchester (N.H.)--Biography. 2. Manchester (N.H.)--History. I. Title.
F44.M2C53 2009
920.0742'8--dc22
[B]
2009019598

To my friend John Jordan,
who has forgotten more about Manchester than I'll ever know…

CONTENTS

Acknowledgements 9

The Accidental Historian 11
The Replacement Child 17
The Blush of Success 23
The Hermit of Mosquito Pond 27
Archie's Pal, Bob Montana 31
The Honorable Frederick Smyth 35
Saturday Nights with Seth 39
The Fraternity Loses a Brother 45
Red's Flying Saucer 51
The Last Boy in Blue 55
101 Angels of Song 61
The Millyard Man 67
The Flag Raiser 71
A Short Story 75
No Man Is Richer 79
Uncle Gus 83
A Monumental Talent 87
For How He Played the Game 91
Double Double Trouble Trouble 95
Byron "Monkey" Chandler 99
The Burger King 105
Sweet Freedom 109

CONTENTS

The Mayor of All Mayors	115
The Joy of Music	119
Peyton Place	123
A Show of Respect	127
The Father of Video Games	131
Adam Sandler's Gift	137
The Fabulous Fay McKay	141
Ferretti's Market	145
The POW Priest	149
The Stark Reality	153
About the Author	157

ACKNOWLEDGEMENTS

This book would not have been possible without the support and assistance of many people. First among them is Joe McQuaid, the president and publisher of the *New Hampshire Union Leader*, who climbed onto a shaky limb when he first asked me to write a column about Manchester. He also granted me permission to use the stories and many of the photographs that appear in this book. Others include:

Bob LaPree, a brilliant photographer, collaborator and co-conspirator, whose work with the camera compels me to try to keep pace with my pen and word processor. Alas, I fail.

My wife, Colleen, and my daughter, Jennifer. They have never shared a dining experience with me that has gone without polite interruption in Manchester. Their patient understanding of the bond I share with my readers and my subjects is greatly appreciated. Besides, that's why they invented the microwave.

My five siblings—Tom, Bob, Mike, Bill and Nancy—who offer ideas, feedback and the constant, drumbeat reminder that success means nothing unless we attain it while living up to the expectations of our dear, departed parents, Bob and Betty Clayton, who were proud, lifelong residents of Manchester.

And lastly, my thanks to the people of Manchester. They fascinate me, they delight me, they challenge me, they inspire me and, most importantly, they honor me with the trust that enables me to share their stories. In order to be true to their stories, they are republished substantially as they appeared in the *New Hampshire Union Leader* and *Sunday News*. Although some of the institutions and individuals in this book are no longer with us, I chose to remember them as they came to me, and accordingly, the dates at the end of each piece indicate the original date of publication.

THE ACCIDENTAL HISTORIAN

Pssst! Want to buy a piece of Manchester's history? Then come a little closer. If you promise to keep it under your hat, I'll let you in on a little secret.

See, I only want my closest friends to know that one of the city's finest memorabilia collections will be going on the auction block Saturday morning at St. George's Catholic Church at 516 Pine Street.

You say you've never been to an auction? It's easy. You just sit there and raise your hand when you want to bid.

You say you haven't raised your hand in a crowd since you had an urgent need to go to the bathroom in the third grade? So don't raise your hand. Just nod your head or raise an eyebrow.

You say you don't have any money? All right already, so don't bid, but if you have so much as a passing interest in the history of Manchester, you won't want to miss the chance to inspect some of the one-of-a-kind artifacts from the personal collection of John Jordan.

For more than twenty years, John has been collecting Manchesterania from all over the United States, enough to fill a small museum, but at 10:00 a.m. on Saturday, when auctioneer Lippy DeRocher steps to the podium, the entire collection—more than a thousand items—will be liquidated.

John's historical holdings include a little something for collectors large and small. He's got museum-quality pieces like: a thirty-eight- by fifty-inch lithograph from the 1859 Manchester fireman's muster, back when Merrimack Common had a pond; an oak-framed charcoal print of Bishop Denis M. Bradley, the first Catholic bishop from the Diocese of Manchester, circa 1905; an 1870 rolled, oil-cloth wall map of the city drawn by James Weston, former mayor of Manchester and governor of New Hampshire; and a stunning, four- by five-foot framed watercolor of the R.G. Sullivan 7-20-4 Cigar Factory, painted in 1922.

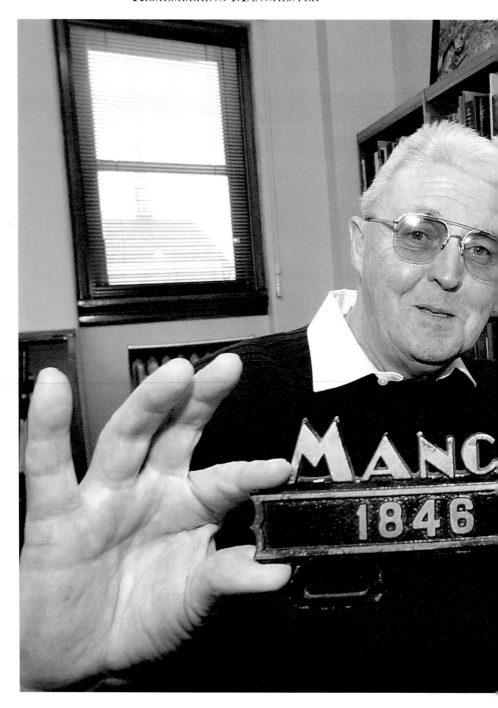

Although his collection of Manchester memorabilia was auctioned off, John Jordan's most precious possession—his local historical recall—is free for the asking. *Courtesy of Bob LaPree/ Union Leader.*

Now don't ask me why, but I have a feeling I won't be hanging any oversized lithographs in my living room Saturday afternoon. Some of this stuff is too good to fall into the hands of kitsch collectors like me, but what promises to make John's auction so much fun is that his collection even includes nifty items for us lowbrow types, such as: an "Amoskeag Pure Rye Whiskey" bottle, circa 1890; handbills from the *Manchester Mirror*, in English and Polish, announcing a ten-dollar fine for spitting on the sidewalk; a framed photo of Mayor Josaphat T. Benoit with a key to the city at the grand opening of the Pulaski Club; and a rare copy of Roland Vallee's 45 rpm record, "Merci, Cherie," dating back to when Manchester's very own "Singing Mayor" was fighting it out with the Beatles for a spot at the top of the charts.

If you ever swam at Nutt's Pond, groped your way through the darkened tunnel at Central High School or enjoyed the panorama of Manchester from atop Rock Rimmon, you're sure to find at least one item to trigger a serious binge of nostalgia, but if you find yourself getting a little bit misty at the memories, just imagine how John feels.

He'll be seeing his collection for the last time.

Part of what makes John's collection remarkable is the man himself. This guy is no stuffy scholar. He's a steelworker, a working stiff just like you and me, and he derives just as much pleasure from a John Kilonis wrestling poster as he does from a pastel painting of Alma's Tea Room.

"I remember I was tending bar at the British American one weekday afternoon, and it was real quiet, so I went looking for something to read," John said. "The only thing I could find was a book on the centennial of Manchester from 1946, so I started looking through it, and I was amazed by the number of things in the city that had simply disappeared."

That was in 1968, and John made a mental note to pick up an item here and there to preserve some of the city's heritage. He started small.

"The first piece I got was at a yard sale," he said. "It was a wooden jigsaw puzzle of the Queen City Bridge, about the size of a postcard."

In the quarter century that followed, John continued to acquire odds and ends, as well as the information that goes with them.

"When we were cataloguing material for the auction, we were looking at a photo from 1870 with about two hundred people in it," said Lippy's wife, Bette DeRocher, "and he just started rattling off the names of the people in the front row. I was amazed."

"He just has an amazing knowledge of the city, and he has assembled and preserved this collection with great care," added Lippy (and I defy you to find an auctioneer with a more appropriate name). "When real estate guys talk about the value of property, they say 'Location, location, location,' but when

auctioneers talk quality, we say 'Condition, condition, condition,'" Lippy said. "And 98 percent of the items in this collection are original antiques from Greater Manchester…John has had a lot of offers for individual items from many people who were aware of his collection, but he felt an auction was the best way for some of these pieces to return to the public domain."

Of course, John had hoped to enter them into the public domain himself. However, with a severe shortage of work and illness besetting his wife, Irene, it's time to give up the dream:

> *I had always thought if I was lucky enough to open my own restaurant some day, I would have plastered the stuff all over the walls. I always thought a place in the Millyard would have been perfect for it, but it just didn't work out that way.*
>
> *In the long run, it was always my intention to donate the whole thing to the Manchester Historic Association, but that didn't work out either. I think calling Lippy was the toughest thing I've ever done.*

John isn't putting everything up for sale. He won't auction his 1939 copy of Ashton Thorpe's *Manchester of Yesterday*, and there's no price tag on his most important historical asset—his memory.

He says you can have that for free.

"Sometimes when people buy something like these items, they like to have a little bit of the history behind it, so I'll be there on Saturday to fill them in if they want the background on anything…It's going to be tough, but I have to go. I'm curious to see who buys what. It hurts, but it has to be done."

February 3, 1992

THE REPLACEMENT CHILD

Lydia (Dyer) Chute may be pushing ninety-five, but to her mind, she'll always be a child.

Not just any child. Lydia is a replacement child.

Her conception, her birth and her very existence is connected to a family tragedy that is tied to Manchester's industrial past, and her smiling presence offers living evidence of a brother she never knew.

That brother, Frank Dyer, died in the Amoskeag Mills. He was just eighteen. He was handsome and popular, a stellar student and an outstanding athlete at what was known then as Manchester High School.

His father, Benson Dyer, was an engineer. He was the superintendent in charge of the new power plant at Amoskeag Manufacturing. Since young Frank had some free time during Easter break, he asked his father if he could work a few shifts and make a few dollars.

It was March 27, 1911.

According to newspaper accounts of the day, Frank had gone into the basement of Amoskeag's new power station at 6:25 a.m., moments before the start of the morning shift. He was headed to a clothes closet to don a pair of overalls. He put the key in the closet door. And then a steam pipe erupted.

It was a twenty-inch steam pipe. It was built to withstand 180 pounds of pressure that would power two mammoth turbines. When the metallic T on the end of the pipe rocketed across the room, the full brunt of the scalding, super-heated steam was unleashed on Frank and two other men.

James Cassidy, fifty-six, of 15 Second Street, died almost instantly. He left a wife and four children. A witness, J.L. Story, told the *Manchester Union*, "I saw Cassidy a few seconds after the scalding, running like a burning man toward a door. The door was shut and he could not feel the knob. He then ran back to the bench and fell dead. Perhaps had the door been open…"

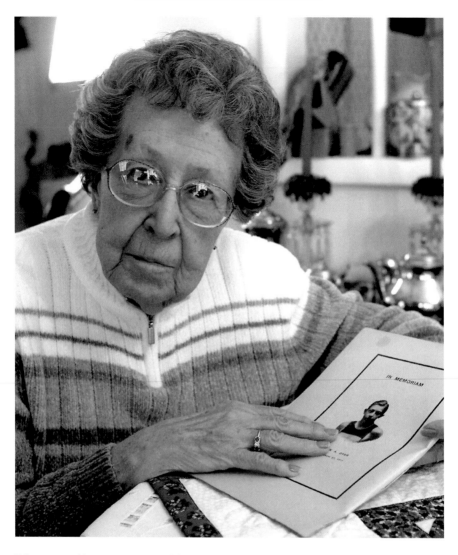

When an accident at Amoskeag Manufacturing claimed the life of Frank Dyer, his parents made a life-affirming choice. Lydia Dyer Chute is the result. *Courtesy of Bob LaPree/*Union Leader.

Horace Crawford, twenty-eight, was in the power plant as a visiting technician with the General Electric Company. He was wrapping up his inspections. He was supposed to catch the 11:00 a.m. train from Manchester to Boston, where his pregnant wife was waiting for him. Instead, at that appointed hour, his lifeless body lay in the morgue at the Sacred Heart Hospital.

Frank Dyer lingered for eighteen hours.

"Death Relieved Boy's Suffering," the *Union* reported. "Heroic to the End," was the subhead, and in the ensuing story, readers learned the fate of the brother that Lydia never knew.

While the others were instantly felled, Frank fought.

"Young Dyer received almost the full brunt of the escaping steam," the *Union* reported,

> *but in his trying ordeal, his head did not desert him in a moment. He acted with judgment in endeavoring to get out of the steam-laden place, and suffering excruciatingly, threw himself into the cooling waters of the canal to find relief.*
>
> *Not once was there any whimpering on his part, and when being taken to the hospital, he showed remarkable courage.*

Courage wasn't enough.

Even though he survived what the paper called his initial "dreadful hurts," he couldn't overcome the secondary effects of the trauma. Doctors at Sacred Heart Hospital believed that he had inhaled the super-heated steam. When he died, they attributed it to those internal injuries.

The subsequent reporting was a tribute to Frank, "a student at the Manchester High School [who] was foremost in all matters of athletics, having excelled in football work and being selected for baseball timber. He was to have appeared on the school diamond this spring."

"Personally, he was liked to an unusual degree," the paper added. "He was considered one of the most popular students of the school, and it was for his many admirable traits that he was beloved by both the faculty and the student body."

Then the paper noted this: "To his parents, the blow comes with particular vehemence and their grief is almost inconsolable."

Frank was waked in the family home at 58 Myrtle Street. After the funeral—the Amphion quartet sang "Shall We Meet Beyond the River" and "Sometime, We'll Understand"—six of his school friends served as pallbearers for the burial at Pine Grove Cemetery.

Having lost their only child, Benson and Cora Dyer did what many parents would do when faced with similar tragic circumstances. They purchased a stained-glass window in Frank's memory. It's at St. Paul's Methodist Church on Smyth Road here in Manchester. The window is called "Jesus Blessing Children."

They also did something else that only the bravest of parents would do when faced with similar circumstances. Both were past the age of forty, yet they did something life-affirming.

They had another child. It was Lydia.

"I don't remember when I found out I was a replacement child," Lydia said when we spoke at her tidy little cottage in Goffstown. "It's just as though I always knew it.

"My mother had come from a family of twelve children up in Canada, and she was the oldest," Lydia explained.

She helped raise her siblings, and for her, I think one child was always enough, but Frank died in March of 1911, and I was born in May of 1912, so I really was on purpose.

I heard that a friend asked her after Frank died why she and my father didn't just adopt a baby, and my mother said, "If I can't have one of my own, I don't want one."

Lydia shook her head and looked away.

"My father was forty-five and my mother was forty-three," she said. "To think they had the courage to have a baby after all that, and at that age. I wouldn't have been here otherwise."

Lydia endured what many replacement children endure.

Her parents—instinctively overprotective—wouldn't let her join the Girl Scouts. Too physical, ergo too dangerous. When she contracted pneumonia at age ten, they withdrew her from public school and enrolled her in a small private school. Less exposure meant less risk, and in spite of the financial risk during the Great Depression, her parents sent her to Boston University.

Materially? Everything they had meant nothing. Emotionally? Everything they had was her.

Throughout her life, Lydia has borne the weight of crushing expectations that sprung from Frank's great potential, and this tiny woman, now ninety-four, has carried the weight with grace.

No one knows this more than her son, Peter Dyer Clark.

Last year, Peter sat down and wrote a seven-page essay about the fate that befell his Uncle Frank—an uncle he never knew—because he wants his siblings and Lydia's vast extended family of grandchildren and great-grandchildren to know the role that fate has played in all of their lives.

"Simply put, without my Uncle Frank being killed, none of us ever would have existed," Peter said. "My mother was born because he died, plain and simple. It was tragic because he was so gifted in so many ways,

and yet, we're all alive because of his tragic death…I've always been struck by that," he added.

"The simple joy of being alive is touched by a kind of guilt," he said. "I've spent decades chewing on that bone, but at the same time, from my Uncle Frank's tragic death—and my grandparents' lifetime of unspoken sadness—has come redemption, life and joy."

When you ask about Frank, Lydia pulls out small boxes, some more than a century old. They contain some of Frank Dyer's awards and mementoes.

There's his first-place ribbon from the YMCA's 220-yard dash, circa 1909. There are honors from Camp Belknap, the green neckties he wore to school, the clever sketches that sprung from his pen and, yes, there is the terrible news clipping that tells of his death.

It's about a brother whom Lydia never knew.

It's a brother whom this replacement child will never forget.

January 8, 2007

THE BLUSH OF SUCCESS

As a rule, I don't wear make-up.

Okay, once in a while. A little eyeliner, maybe a touch of blush, but only if I'm wearing that snappy little blue chiffon number for a big night on the town. Never on the job though.

Nope, in professional media circles, make-up is pretty much the exclusive domain of the TV guys at WMUR—hello there, Tom Griffith!—but if ever I decide to make a major move to cosmetics, my brand of choice will certainly be Revlon.

Go ahead, call me a homer—that's *homer*—but I figure if I'm going to put anything on my cheeks but the blush that God gave me, I'll use the rouge that has its roots right here in Manchester.

That would be Revlon.

Yes, the company that gave America the revolutionary pre-feminist concept of "matching lips and fingertips"—not to mention truly fabulous "Revlon Girls" like Candice Bergen, Lauren Hutton and (gasp!) Cindy Crawford—has undeniable ties to our town.

More specifically, those ties bind Revlon to a sprawling three-story tenement at 170 Conant Street—conveniently located near Fritzie's Market—that was home to Samuel and Jeanette Revson (please note the spelling) and their three sons, Joseph, Charles and Martin.

It was 1910 when they first moved into those modest digs, and today, a mere eighty-four years later, the memory of those humble roots has faded like a bad dye job, and that's because the Revson boys took the old "rags to riches" theme to near comical extremes and created the world's most successful cosmetics empire.

And how did they do it?

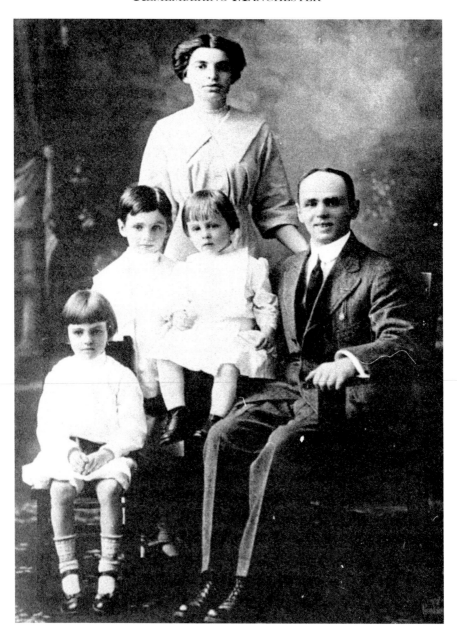

Back when they lived in a West Side tenement on Conant Street, the future founders of Revlon found time to pose with their parents. Martin Revson is the youngest. *Courtesy of Martin Revson.*

Towering Titans and Unsung Heroes

Well, that's the $64,000 question, a Revlon reference that may come up again before we're through here. To get the answer, I went right to the source and called Martin Revson, now eighty-three, whose stupendous good fortune in business may have been offset by the simple fact that he had the great misfortune to be home when I phoned his Manhattan penthouse.

"How did we do it? I like to think we invented a new industry," he said. "It's like something Henry David Thoreau once said. We said we were trying to reach women who were 'leading lives of quiet desperation,' because we knew that women who were buying cosmetics were also buying hope."

It's hard to put hope in a jar. But remember: it was 1931 when the Revsons first got into cosmetics. This was an era when a woman wearing false eyelashes looked like she was smuggling anchovies. Never mind the incredible double standard—a man was considered stylish if he merely removed the wads of toilet paper from his shaving cuts—the concept of "hope" was fertile turf, and the Revsons plowed it for all it was worth.

I discovered this fact in a corporate biography entitled *Fire and Ice*. It was written by a knucklehead named Andrew Tobias who actually implied—heck, he wrote it outright—that the Revsons had to overcome adversity from the get-go because "the West Side of Manchester was the wrong side of the Merrimack."

I'll deal with that Tobias goofball later, but *Fire and Ice* does follow the same path as the Revsons, all the way from Conant Street to Park Avenue.

"We all went to the Varney School," said Martin, "but when it was time to go to high school, Joseph and Charles had to walk across town every day to go to Central. I had it easy. They opened West High just in time for me."

As such, Martin got to rub shoulders and bump helmets with others who would make indelible marks in our little world, like burger magnate Richard McDonald and aviator Jean Grenier.

"I was a substitute quarterback on the first football team at West," Martin said, "and when I look at the pictures, I don't even know how I made the team. I was so small they used to call me 'Midge,' which was short for midget."

His rise from football midget to corporate giant began in 1925, when the Revson family moved to New York.

By 1931, his brother Charles started selling nail polish, and ten years after leaving Manchester, the brothers were united under the corporate flag of Revlon. The division of labor was thus: Joe managed the money, Martin managed the advertising and Charles, the alpha dog, managed to make himself the scariest man in make-up, unless you count drag queens. Or Milton Berle.

For years, the company operated on the simple premise of "selling class to the masses." From nail polish, they sidled into lipstick and then into hair spray. Each year—just like General Motors—they introduced new models and new colors (like "Plumb Beautiful") and new promotional gimmicks like the "Fire and Ice" quiz.

"Are you made for 'Fire and Ice?'" That's the question that was posed by a glamorous lipstick model in a two-page magazine spread aimed at housewives. You were made for "Fire and Ice" if you answered "yes" to at least eight of the fifteen hot-and-sweaty questions that followed, such as "Have you ever wanted to wear an ankle bracelet?" or "Do you close your eyes when being kissed?"

It sounds tame now, but hey, in 1950 this was racy stuff. Martin Revson was pushing the edge of the envelope and the public lapped it up. Talk show hosts from Arthur Godfrey to Dave Garroway to Steve Allen couldn't wait to give the quiz to their female guests, and after the furor of the fifteen questions faded, Revlon posed another question—*The $64,000 Question*.

"It was in 1955," Martin said. "There was a TV show called *This Is Your Life* and it was hot as hell. The sponsor was one of our competitors, Hazel Bishop, and they were murdering our lipstick business. There were only two channels back then, so if you had a hit show, more than half the country would be watching."

Revlon needed a hit of its own, so Martin swung for the fence. He convinced his brother Charles to sponsor a little quiz show hosted by Hal March called *The $64,000 Question*.

"It would run Tuesday nights at ten," Martin said, "and by Wednesday morning, whatever we had in the stores would be flying off the shelves. In 1954, we did $33 million. The next year, we did $55 million. The year after, $85 million. I venture to say I don't know where we would have been without that show."

Back on Conant Street? We'll never know.

What we do know is this: the Revson brothers—equipped with nothing but guts, hustle and precisely the kind of education I got in Manchester's public schools—were able to turn a $300 investment into a global cosmetics empire valued at half a billion dollars before they moved on.

It's enough to make me blush.

Even without make-up.

February 7, 1994

The Hermit of Mosquito Pond

I'm sure you'll be giddy to learn that there's yet another book coming out about Greta Garbo, the famous dead movie star whose primary claim to fame was that she hated being famous.

If you remember this husky-voiced Swede for saying, "I vahnt to be ah-lone," you should know that she was misquoted. Apparently, that was the *Reader's Digest* condensed version. What she really said, according to the latest bio by Barry Paris, was "I vahnt to be *let* ah-lone."

As if it matters. If you wanted to be a recluse, would you move to a toddlin' tabloid town like New York? That's what Garbo did, the ninny. If you wanted to be alone, you'd move to a place so ghastly that no one would want to be near you. If you wanted to be a hermit, you'd move to an inhospitable locale where the name alone would be enough to scare people off. For instance, there's Sucking Chest Wound, Wyoming; Pork Tartare, Pennsylvania; or Lawrence, Massachusetts.

You can see, therefore, why our very own Charles Lambert was so much smarter than Garbo. Sometime in the 1840s, when he decided that he'd had enough of what passed for civilization in Manchester—there wasn't much back then, either—he put out the fire in his wood stove and hauled ash out to a place called Mosquito Pond.

Sounds ghastly and inhospitable, doesn't it? Still, I like it a helluva lot more than the name we know it by today. That would be the lamely named Crystal Lake. Pardon me while I stifle a yawn. I mean, how boring is Crystal Lake?

Every stagnant duck pond and every bilge-filled backwater in America is called Crystal Lake. I'll bet there are four billion Crystal Lakes in Minnesota alone—the Land of Ten Billion Lakes—but how many places have a Mosquito Pond?

I'm pondering a petition drive to have the old name reinstated, but meanwhile, let's get back to the Hermit of Mosquito Pond.

As hermits go, Charles Alban Lambert should not be confused with some of the solo artists you see keeping their own company on Elm Street these days. I prefer to think of them as urban hermits—sounds like an oldies band—but Charles was a true hermit who preferred a life of solitude in the country.

He was born in 1823 in Lincolnshire, England, where his family raised sheep. They also raised children—he was one of fourteen—so those of you who have ever had to wait in line to use the bathroom can probably understand why he felt such an overwhelming urge for privacy later in life.

Apparently, Charles also preferred beef to lamb, because he left the sheep farm and boarded a cattle boat to come to America at the age of eighteen. Records show that he had set his sights on a career in law but came to his senses just in time to be knocked senseless by love. At least that's what a reporter from the *Manchester Daily Mirror* surmised.

"From the lonely life he has led and his evident aversion to the company of the opposite sex," the reporter wrote, "the world at large is imbued with the idea that he was unfortunate in some attachment formed when he was young."

In other words, he got dumped by some Fillmore-era filly—women, you can't live with 'em, etc., etc.—and he headed for the hills.

These hills were in southeast Manchester in the area of Little Cohas Brook, where he built the ramshackle cabin he called home. The poet in me wants to refer to his bungalow as the Hermitage, but that was the name of Andrew Jackson's shack down in Tennessee, not to mention a famous museum in the polymorphous Russian city of St. Petersburg, which became Petrograd, which begat Leningrad until, at last glance, it was St. Petersburg again.

Once he had settled in, Charles fell back on old family habits and started raising sheep. And vegetables. And eyebrows.

Yes, as word of the hermit's existence began to spread around town, the curious would furiously pedal their bikes out toward the forty-acre spread that he had amassed just to get a look at him. From a distance, he probably looked like a crazy old coot—his "separated at birth" match would be Charles Manson—but those who got close enough to peer beneath the layers of grit and grime found a remarkable free spirit.

Like some religious hermits, he was an ascetic of sorts. He lived on a spartan vegetarian diet of peas, squash, corn and the like—I was only kidding about him preferring beef to lamb—while avoiding the temptations of coffee, tea, alcohol and tobacco.

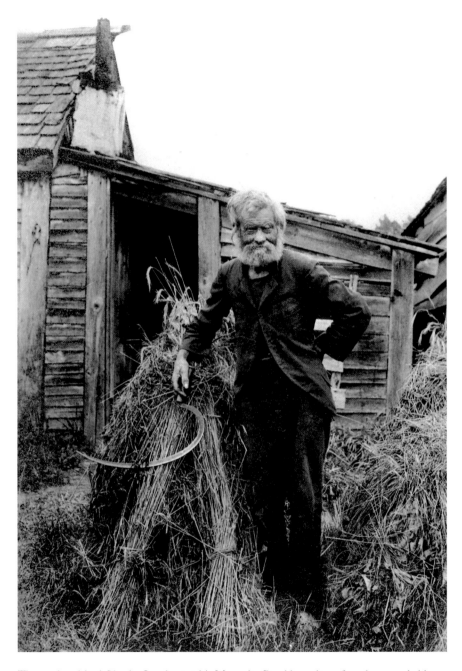

Those who visited Charles Lambert at his Mosquito Pond hermitage found a remarkable free spirit living beneath the layers of grit and grime. *Courtesy of Ulric Bourgeois/Manchester Visual History Collection.*

He was fluent in flora and fauna and raised many medicinal roots and herbs, which he sold to druggists and chemists for the manufacture of medicines. He further enhanced his independence by selling the wool from his sheep and the pelts of the animals he trapped. He was like a walking, talking Earth Day celebration unto himself, but the details of his existence might have been lost forever if not for the equally remarkable Ulric Bourgeois.

Bourgeois was a French Canadian immigrant who worked as a photographer at Varick's Hardware Store. Upon reading accounts of the hermit's lifestyle, he bundled his glass-plate camera onto his bicycle and set out to meet Charles Lambert. Here's how Manchester photographer and historian Gary Samson describes the result.

"Bourgeois developed a narrative cinema-like approach to telling the hermit's story in photographs," Gary wrote. "Virtually every aspect of Lambert's existence from season to season was documented in a style that belied the presence of a large tripod-mounted camera and an operator maneuvering glass plates in order to capture the moment."

For a dozen years, Bourgeois recorded the hermit's daily routines. There are portraits of Lambert harvesting his crops, tending his traps, reading his poems and washing—albeit infrequently—in the waters of Mosquito Pond. His glass-plate negatives also caught the hermit entertaining visitors, because unlike some of the surly urban hermits who live under bridges and in major appliance cartons, Charles Lambert was bright and engaging and enjoyed the company of others, so long as it was on his own terms.

It was only in the later years of his life—when his health began to fail—that his independence faltered. Even then, after Bourgeois had helped arrange for the eighty-nine-year-old hermit to be treated at the Sacred Heart Hospital, he slipped back into the woods from his quarters in the House of St. John's.

In the end, he counted on the Sisters of Mercy for his care until his death in 1914. In his will—he knew the law, you will recall—he left all of his property to St. Patrick's Orphanage in Manchester, but his gift to the rest of us was his legacy of fierce independence as chronicled by Ulric Bourgeois.

April 24, 1995

Archie's Pal,
Bob Montana

Whated I was a kid—and please remember how much I love my hometown—I harbored a secret wish that one day my family would move to Riverdale.

I wanted to hang out with Archie. You know, Archie Andrews, like in the comic book.

Yes, Archie, that eternally boyish, perpetual high school junior who proved on a daily basis that Riverdale was better than a male *Fantasy Island* in that the women there—Betty and Veronica in particular—actually fought over the men. (For the record—and this is a pivotal, soul-baring, "either or" choice that provides more definitive insight into the individual male psyche than any Rorschach test could ever reveal—I would have chosen Betty.)

All the better then that the idyllic village of Riverdale was the vision of Bob Montana, the Central High School graduate (class of 1940A) who never lost the ability to convey the sense of joy and wonder and absurdity that is high school.

"To me, Bob Montana and 'Archie' are Manchester's best-kept secrets," said syndicated cartoonist Larry White. If so, the secret was out when the Manchester Historic Association recently held a commemorative presentation on Montana's work, including original strips, early samples of his drawings and a discussion featuring White and longtime Montana collaborator Jeff Cuddy.

"It was really a great privilege to work with him," Jeff Cuddy said, "because he taught me everything I know about comics. When I was learning his technique, I would stand at his shoulder and watch him and he was just so deft. He could just make those characters come alive."

In many ways, they are still alive.

So pervasive is the Archie influence in America that in the formative years of our most cutting-edge source of information—that being the

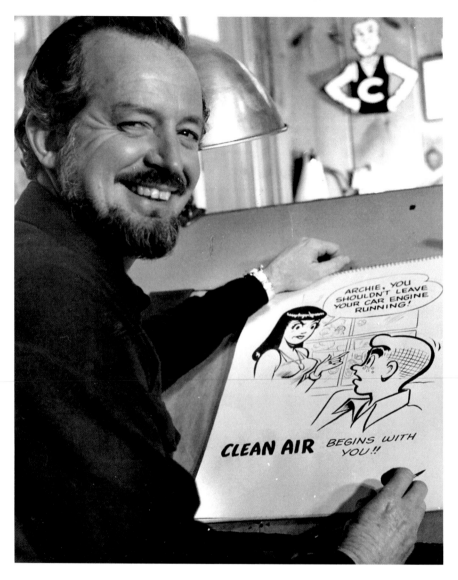

Bob Montana and the cast of characters from *Archie Comics* are among "Manchester's best-kept secrets," according to syndicated cartoonist Larry White. Union Leader *File Photo.*

Internet—programmers came up with a tool for searching archives. Naturally, they named it "Archie."

Not long thereafter, Archie and Veronica (that vixen!) wound up on the cover of *Yahoo!*, a leading Internet magazine, and then came word that filmmaker Tommy O'Haver—a big hit at a recent Sundance Film Festival—was set to write and direct a musical comedy based on Archie and company.

Not bad for characters who have been around since 1941.

That's when they were first liberated from Bob Montana's imagination. With an alleged nudge from MLJ publisher John Goldwater, Bob's vision of the typical American teenager made a near simultaneous debut in two comic books—"Pep" (#22) and "Jackpot" (#4) for you collectors out there—and by the fall of 1942, the comic book had Archie's name on top.

Of course, by that time Montana was serving with the U.S. Army Signal Corps. Upon his discharge in 1946, at the behest of King Features Syndicate, he moved *Archie* from comic book to newspaper strip, which is the reverse of the normal order on the road to global renown.

At its peak, *Archie* appeared in more than seven hundred newspapers worldwide, and let's not overlook the proliferation of comic book spinoffs like *Archie's Joke Book, Archie's Pal, Jughead, Archie's Girls, Betty and Veronica* and so on.

"Since it caught hold, *Archie* has been the largest selling non-superhero comic in the world," Larry White said. "It's always been a good, clean comic that's been safe for the kids, but adults enjoyed it so much they even came out with a series of miniature books so it wouldn't look like they were reading comic books."

Such concern for appearances would not have troubled Montana, who was delightfully nonconformist. Perhaps that's to be expected from a man who—as the son of traveling vaudevillians—was born in a proverbial footlocker. His mom was a Ziegfeld girl named Roberta Pandolfini, and his father was a banjo player named Ray Coleman who took, as his stage name, "The Great Montana."

The name stuck with the son. So did the entertainer's mind-set. And when fate brought Bob to Manchester from Haverhill, Massachusetts, the Queen City simply became the confluence for rivers of talent and timing.

Naturally, such genius cannot function in a vacuum. Once established in the postwar era, Montana settled in Meredith, New Hampshire, but his palette was continually enriched by family globetrotting. Prolonged stays in Mexico, Spain and Italy provided him with fresh ideas for the strip, as did the family itself.

"He had four children," said Jeff Cuddy, "and he told them, 'Anyone who has an idea, put it on the refrigerator and I'll give you a quarter.'"

Certainly Montana struck a more lucrative arrangement with his assistant, Ruth Harding, the Maine native who not only lettered the strip but also offered situations and notions for the characters that Montana would then flesh out.

By 1962—after creating an Archie mural in the Manchester eatery called the Deli-Rama that delighted Montana—Jeff Cuddy was added to the mix as an inker and finish artist. That threesome thrived until Montana's sudden death in 1975—he suffered a heart attack while cross-country skiing—at the age of fifty-five.

In an effort to keep the strip in New Hampshire, Jeff picked up the mantle, but after a few weeks, he graciously bowed out.

"Bob was a genius," he said. "I couldn't keep up."

Who could? Over the years, the demands of this demanding trade have grown exponentially. With *Garfield* creator Jim Davis now presiding over a team of thirty-five artists and writers, one can only marvel at Montana's singular ability to create such a memorable stable of characters.

Bet you still remember them.

In addition to the headliners we've already mentioned, there's the oleaginous Reggie Mantle, lunkhead Moose Mason, goofy Big Ethel Muggs, the crotchety Miss Grundy and the buffoonish and balloonish principal, Mr. Weatherbee. And who could forget that prototypical cafeteria crone, Miss Beazley?

(And just to prove no good deed goes unpunished, when the American Society of Dietitians begged Montana to replace Miss Beazley with a more attractive character, he complied. He was then besieged by readers, who wanted him to restore his less-than-comely creation. Eventually, he bowed to the wishes of the majority.)

In the end, however—at least in these parts—Bob Montana's most enduring creation may have been Bob Montana himself, and I've got a good mind to throw an Archie-style sock hop in his honor.

Why, I might even bring a date. Anyone know Betty's phone number?

March 30, 1998

THE HONORABLE
FREDERICK SMYTH

Given what I do for work, it should come as no surprise that, at the moment, one of my most treasured possessions is a book.

It's an old book, and I treasure it because it once belonged to my paternal grandmother, Sadie (Wright) Clayton, who made the book all the more precious to me when she inscribed her name inside the front cover.

I also treasure it because it's a publishing oddity, one in which the cover was incorrectly affixed to the text. As a result, when I hold the book to read it—much like that old *Mad* magazine gag—the cover is upside down, so anyone who sees me reading it will think I am an illiterate or a loon or both.

I also treasure it because it is a biography of Frederick Smyth, and if you made a shortlist of people from Manchester who were deserving of a leather-bound biography, his name would be on that list.

It was Frederick Smyth who, upon being elected mayor of Manchester in 1852 at the tender age of thirty-three, said, "I fear I may fall far short of the expectations of my fellow citizens who have placed me in this responsible position."

Humility in a politician? Yikes!

It was Frederick Smyth who brought the Queen City its first water and sewer systems, its first streetlights and its first sidewalks. He is also the man who, "against considerable opposition, obtained the authority of the city council to set trees on Elm Street and [on] land owned by the city."

It was Frederick Smyth who, before a Manchester audience in 1860, had the temerity to introduce a gangly legislator from Illinois as "the next President of the United States"—not Barack Obama; it was Abe Lincoln—and it was Frederick Smyth who introduced yet another president, Rutherford B. Hayes, to a new-fangled contraption called the telephone.

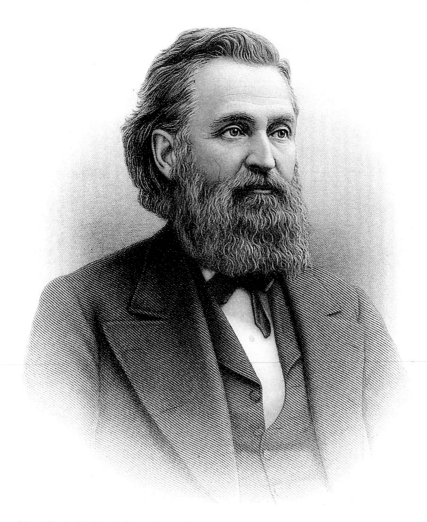

Since Frederick Smyth brought the Queen City its first water and sewer systems, plus its first streetlights and its first sidewalks, it's understandable why he would be the subject of a comprehensive biography. *Courtesy of Frederick Smyth Institute of Music.*

That last introduction took place at the Smyth mansion called the Willows. It was situated near the Amoskeag Bridge where the Brady-Sullivan Tower—formerly known as the New Hampshire Insurance Building—now stands, and there are preservationists here in the city who still weep when they talk about the razing of that once-glorious mansion.

Clearly, this is a man whose deeds were worth chronicling, which is what happened in 1885 when Benjamin Perley Poore and F.B. Eaton collaborated

on the book they called *Sketches of the Life and Public Services of Frederick Smyth of New Hampshire*.

If you were to read it from the beginning—and you'd be surprised how few people do that—you would discover that this noted man of Manchester was actually born on a farm in Candia, on which "these hardy tillers of the rock-bound soil produced—with the aid of their wives, daughters and sons—every article eaten in or worn by the family."

Charming though it may be, Candia offered little for a man of Smyth's ambitions, so he came to Manchester, where he quickly made a fortune in the mercantile and banking trades and—at the age of thirty—retired to a life of public service.

His four terms as mayor were not without their controversies. City councilors balked at the extravagant notion of paying for city sidewalks, for example, and Smyth's efforts to upgrade conditions at the House of Reformation for Juvenile Offenders were derided as "a $40,000 Palace for Prostitutes"—bet that headline got some pulses racing back in 1855. But it was a time when Smyth was out of office, as was the case in July 1863, that his true commitment to public service was even more in evidence.

"After the Battle of Gettysburg, he hastened with others to that bloody field," noted the authors of the previously mentioned *Sketches*, "where he labored among the wounded soldiers until he was himself prostrated by exposure and over-exertion."

"The sickening effluvia of the battlefield, the sounds and sights of distress beyond all human aid brought him to a sick bed where he was confined during most of the fall of 1863," the authors added. And yet, the next May—even after he "reluctantly assented" to serve that fourth term as mayor—"there came news of the horrors of war as displayed at Fredericksburg, and Mr. Smyth again hastened to the front to help carry wounded from the field, some declaring, under God, that they owed their lives to his tender care."

Now, before you think I am seeking to beatify Mr. Smyth, you should know that he and I were of different minds in some critical areas. These areas include cussing and drinking.

First of all, he thought that the people of Manchester were a bit coarse in their pubic discourse, which he noted after his first trip abroad.

"I have not heard so much profanity since I have been in London as may be sometimes heard in Manchester in one day," he wrote, "though I daily pass a crowd three miles long."

And as much as he disliked swearing, he abhorred drinking.

"From that day in which I first assumed the responsible position conferred upon me by the people of New Hampshire," he explained to a crowd at

Dartmouth College during his second term as governor, "I resolved not to furnish intoxicating liquors to my guests or friends on any occasion, public or private, or partake myself...When called upon to drink at public dinners in response to patriotic or friendly sentiments," he added, "I have invariably used cold water, the best drink—for a cool head, a clear mind and a good conscience—ever given to man."

So he didn't cuss or enjoy a touch of the grape? These are minor quibbles between me and the man who still continues to serve the people of Manchester more than a century after his death. That service comes in the form of the Frederick Smyth Institute of Music, which provides scholarships for students in the city high schools who choose to study music.

It's just one more reason to sing his praises.

February 16, 2009

SATURDAY NIGHTS
WITH SETH

L IVE! From Manchester! It's Mondaaaaay morning!
 So, let's see now, there's Chevy Chase, John Belushi, Dan Aykroyd, Jane Curtin, Bill Murray, Eddie Murphy, Billy Crystal, Chris Rock, Mike Myers, Dana Carvey, Chris Farley, David Spade and Tina Fey, but around here, the only alumnus of NBC's *Saturday Night Live* who carried any weight was Manchester's own Adam Sandler.

And now there is Seth Meyers.

Once again, Manchester has local representation in the cast of *SNL*, and the question before us is whether Seth—a 1992 West High graduate—will be the next of the "Not Ready for Prime Time Players" to use NBC's late-night ensemble comedy showcase as a springboard to achieve major fame and fortune.

Only time will tell.

But, in no time flat, Seth made his mark on the twenty-seven-year-old program—it's as old as he is, by the way—when he took to *SNL*'s "Weekend Update" anchor desk on the eve of the seventh and deciding game of the 2001 World Series and told the world why the New York Yankees—sentimental favorites in the wake of 9/11—were in trouble.

Some experts blamed an aging Yankee pitching staff. Others cited an inconsistent offense. Seth hit the ball out of the park.

"It's because, for the first time in history, Red Sox fans are rooting for the Yankees to win," he explained with mounting passion. "I know. I'm a Red Sox fan. For the past eighty-three years, you've had nothing but our negative energy and hatred, and it's led to, like, sixty-five world championships."

In an effort to save the Yankees, Seth called on Roger Clemens, karma and the Curse of the Bambino to defeat the Arizona Diamondbacks, but still, in his heart of hearts, he knew that we Red Sox fans and our black cat baggage were sure to drag the Yankees down.

How bad are we to have on the bandwagon?

"If Boston rooted for gravity," he explained on air, "we'd all be floating three inches off the ground."

By the way, the Yankees lost the Series.

But with that one reasoned bit of on-camera oratory, Seth Meyers won the hearts of the *SNL* audience, an audience that begs for the show to be: one, funny, and two, relevant.

Nothing is funnier (in a dark way) and more relevant than the travails of the Red Sox, but what made the appearance so relevant around here is the fact that instead of masking himself as some deranged commentator, Seth played Seth.

"That's why that was a highlight for me so far," he said as he smiled his killer, movie-star smile. "To be yourself on camera reading something you wrote and to have your name up there on the screen at the same time? It was pretty nice…It was also nice to tell nine million people you were a Red Sox fan, all at the same time," he added. "I've been doing it one at a time, but it was taking forever."

Success has come a bit more swiftly. Not overnight, mind you, but swiftly. After having graduated from West, Seth earned a degree from Northwestern University and then worked with a traveling troupe called Boom Chicago.

Eventually, the road took him to Amsterdam, where he was the writer and co-star of a two-person comedy show called *Pick-ups and Hiccups*. With Amsterdam as his home base, he did versions of the show in London, Edinburgh and Singapore, but it was during a brief run at the Chicago Improv Festival that he caught the eye of an *SNL* casting director. He was invited to New York for a tryout and then a follow-up; then he was hired.

Success? Not in his mind.

"The biggest mistake you can make," he said, "is to get a job on *Saturday Night Live* and say 'I made it!' You just took on the hardest job of your life, and you can't look at it as some kind of culmination. You have to focus on the work."

He gets to work by subway from his apartment in the West Village. Once he gets there, it's hard to leave. There is a constant, breakneck pace to producing a live, weekly television show, and Seth has already found that necks are not the only thing that can be broken. Your spirit is also on the line every day.

He sees three distinct "Windows of Rejection."

"A typical week?" he asked.

Monday, we have the host come in. We go into an office and the writers and actors get together with them to pitch ideas. That's the brainstorming.

Towering Titans and Unsung Heroes

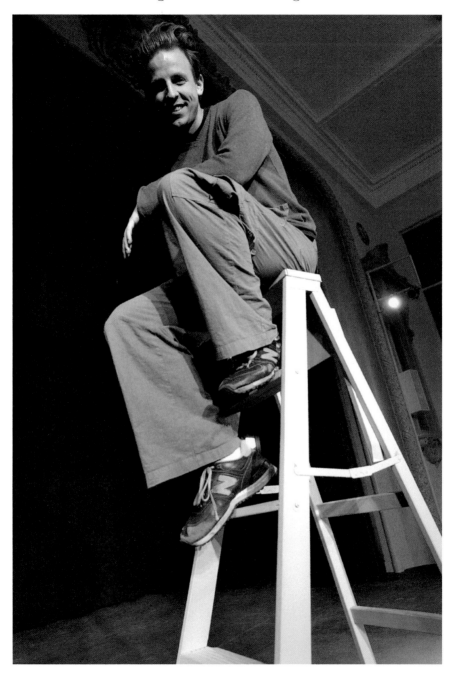

With his ascension to the position of head writer on *Saturday Night Live*, the career of West High graduate Seth Meyers is really on the rise. *Courtesy of Mark Bolton/*Union Leader.

Tuesday is our writing night. We're usually in the office until seven in the morning because everything has to be done by nine on Wednesday.

That's when the interns come in. They download the scripts, print up the packets and by four on Wednesday afternoon, we do the read-through. There are forty people at the table, and things live and die right there. That takes four hours. At the end of the night, the list comes out and says what we'll take to dress rehearsal.

That's Rejection Window I.

That's the first hit of the week, especially if you had an idea you were close to. You worked it all week and all of a sudden, it dies.

Thursday and Friday, we rehearse. Saturday, we do a run-through during the day to make sure the cameras are right and then at eight, we bring in a full audience and instead of a ninety-minute show, we do one that runs two hours and fifteen minutes. Then they post a list of what's in and out for the live show at 11:30.

That's Rejection Window II.

"It's like seeing if you made the high school basketball team," he said. "You've built a set, made the costumes and run it by an audience and now it's cut? Brutal."

But the show must go on. That means the cast members fly through make-up and skits and interact with the hosts—like Gwyneth Paltrow and Billy Bob Thornton. The clock is winding down, the hour is approaching one o'clock in the morning and look, there, waiting in the wings, it's not his mother or his father or his brother, Josh. No, it's Rejection Window III.

"It's the most brutal of all," Seth said. "Each of the last three shows, the last sketch has been cut because of time. The show ends at one. That's live TV."

It's live, it's a living and Seth Meyers is loving it.

That was obvious when he was recently walking the halls at West High. He'd come home for Thanksgiving, and he was visiting with some of his favorite teachers, like Walter Lubelcyzk, Brad Duffy and the recently retired Joe ("Column as I See 'Em") Sullivan.

"I got there about twenty minutes early," Seth said, "and I was standing outside Mr. Duffy's class just listening through the door. That's when you realize that good teachers are performers. There's a charisma and a cadence. They're doing forty-five-minute shows six times a day."

If that's true, there may be a genetic code to Seth's calling.

Towering Titans and Unsung Heroes

While his dad, Larry Meyers, works with General Electric Trade Finance, his mom, Hilary Meyers, is a legendary French teacher at McKelvie Middle School in Bedford who is known almost universally throughout the town as "Madame Meyers."

Seth is eager to share his success with those people—his folks, his brother and his teachers—and also with the countless classmates who boldly predicted success, even when his biggest gig was the "Winter Follies" on stage in the West High Auditorium.

"That's why I'm home," he said.

> *The sharing is the best part of it. When I was here at West, we'd do a comedy show and people would say, "One day, I'll be watching you on* Saturday Night Live," *and you'd shrug it off. Never happen, right? Maybe now those guys can feel like they're a part of this.*
>
> *Now they can say they knew all along, and I can honestly say I was the dope who didn't have the confidence to think I'd be on* Saturday Night Live.

November 26, 2001

THE FRATERNITY LOSES
A BROTHER

Here's something you need to know about Dave Anderson. The Manchester firefighter who died on December 23, 2000, was no saint.

Ask any of his fellow firefighters. They'll tell you. They'll smile when they tell you that, saint or not, he's entitled to a special place in heaven, and woe unto anyone who would say otherwise.

It's now Saturday afternoon. It's just after four o'clock. We're at the Wild Rover Pub. My brother Bill called me to join him. He was with about a dozen of his fellow firefighters—some from Manchester Local 856, others from the state chapter of the Professional Firefighters of New Hampshire.

They've gathered to work on logistics for Dave Anderson's memorial service. The wound of his loss is still fresh—barely eight hours old—but a kind of numbness has set in, and there are countless details to attend to, both minor and monumental.

Among them? Naming pallbearers and ushers, securing accommodations for thousands of visiting firefighters, staging a massive parade, meeting the demands of the media, coordinating schedules for visiting dignitaries, scheduling mutual aid coverage so that every single Manchester firefighter can attend the service and booking a hall large enough for a mercy meal for more than two thousand mourners.

That's what brought them to the Wild Rover. At least, that was their official mission.

What they're really doing, perhaps without even realizing, is holding an Irish wake for the larger-than-life character they know as "Ando."

So the cellphones are chirping, the flowchart is growing and the clock is moving, and these men who are so task-driven are now wrestling with a task that they had hoped never to address. But they do so, and then it's five o'clock and the beer is starting to flow—so are the stories. Stories about Ando.

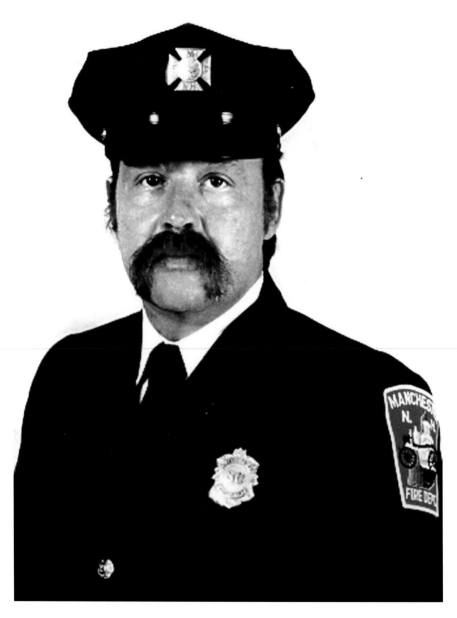

The late David Anderson was no saint, but in the wake of his death, woe unto anyone who would say otherwise in front of his fellow firefighters. *Courtesy of Manchester Fire Department.*

Towering Titans and Unsung Heroes

If Dave Anderson has a polar opposite on the Manchester Fire Department, it is Lieutenant Steve L'Heureux. Where Steve is neat, slender, articulate and by-the-book, Dave is loud, burly, brash and, at times, hysterically profane, but firefighting is a fraternity and it is a fraternity that produces extraordinary pairings.

This is one of them.

"When Kevin Healey and I were on the Rescue on Group One, Dave used to tell us that whenever we needed help—if we were trapped anywhere on a roof or a balcony—it was like Disney World," Steve said. "Any ride down in the bucket was a five-ticket ride. For years, Kevin and I carried those little raffle tickets in our helmets. Five of them. You know. With him…just in case," he added.

So now it's 1997.

Steve is on a burning roof on Lake Avenue alongside firefighter Kenny Prince when suddenly—through the thick, white fog of smoke—the bucket from the snorkel truck looms in the air before them.

"I just looked at him," Steve smiled,

> and I remember thinking—I always called him Hondo, and I remember thinking—"Hey Hondo, how many tickets for a ride down?" I didn't even say anything, and he yelled, "It's five tickets, you blanking bird!" I didn't need the lift, but I knew if I did, he was my ride down.

Dave Lang is a firefighter from Hampton, but he is also an officer with the Professional Firefighters of New Hampshire. As such, he is very mindful of the image of firefighters, and even though he has a small smile on his face, he is trying in vain to suppress the flood of irreverent Dave Anderson stories.

They are in a bar, however—firefighters in a bar—and it would be easier to stem the flow from a two-and-a-half-inch blitz line.

Dave Anderson is a guy who takes big bites out of life, so first it's the saga of the annual fishing trip, then tales from various goings-on at the Fireman's Ball and then folklore from a yearly pig roast, but much to Dave Lang's relief, it keeps coming back to the job.

"He'd go deep into the flame," said Jean Brassard, offering up the ultimate compliment that one firefighter can bestow on another. "You didn't have to worry about him when he was at a fire. He'd look after the guys with him, and he'd go deep into the flame."

Here's something that you should know about my brother, Bill. Okay. Two things. Back in the '80s, he was Dave Anderson's working partner for eight

years, and he does not tell fire stories. Ever. His record is intact. This is a post-fire story.

"We had this fire that went all night," Bill said, and as he said it, Dave Lang cringed, but my brother—who never tells fire stories—pressed on anyway.

"It was a good stop," he said, "a good save, and we got off at seven-thirty in the morning. There was no place open at that hour, and I was living in an apartment on Bell Street, so four or five of us went over there, and pretty soon, well, there's more than a few empties on the kitchen table. Then there's a knock on the door."

He opened the door, only to find two clean-cut and extremely sincere visitors of a nonspecific religious faith. Their mission?

"I think they said something about us being saved," Bill said. "That's when Dave waved them in. 'Hey!' he said. 'You birds want a beer?' I think he figured we had a better chance of converting them than they had of converting us. They left two hours later. All I can say is, no souls were saved that day."

Now it's nearing the top of the hour, and the images that herald WMUR's 6:00 p.m. newscast are starting to flash on the big screen TV at the Rover. Chris Delaney has come in to tend bar and—clearly aware of what's been happening around him—he hits the volume button on the TV.

Every firefighter is turned to the screen.

Anchor Kate Amara tosses the story to reporter Tara Mergener, who talks about the fire at 34 Elm Street, the loss of seventeen-year-old Patrick Flannery and the critical injuries to Mathew Flannery. Slowly, gradually, the background commotion in the bar seems far away.

Then reporter Sean McDonald is talking about Dave Anderson, and there is a growing silence throughout the bar. There is a weight in the air. Without a word, patrons sense that weight. The jukebox is still. The bar falls silent but for the TV.

Now every customer is turned to the screen.

First, Chief Joe Kane is on that screen talking about Dave Anderson, then it is firefighter T.J. Blanchette, then it is Lieutenant Bruce Phillips, then it is Captain Mike Gamache and then it is Andy Parent.

Ordinarily, the sight of a firefighter on television at the Rover triggers hoots and catcalls from the brethren because it is an unspoken rule among firefighters that one does not seek nor does one willingly accept publicity, and pity the one who is foolish enough to be caught in that spotlight.

No hoots today. No catcalls. Just a dozen brave men fighting back tears. Some do it better than others.

I am a lucky man.

Towering Titans and Unsung Heroes

Three of my brothers are firefighters. For that reason, and that reason alone, Manchester firefighters have constantly honored me with their embrace, but with that embrace comes an understanding, an understanding that if you will share in their bachelor parties, weddings, softball games, football pools, food, beer and enviable lust for life, when the time comes, so too will you share in their grief.

And now they are grieving. It is unbearable to watch.

It is unbearable to watch these brave men confront the terrible reality of what they do, because what they do demands that they fight both fire and fear on a daily basis, and on this day, their worst fear has come to pass. One of their own has fallen, and every one of them knows that there but for the grace of God…

One by one, they try to talk.

Then they try not to talk because to talk is to reveal the catch in the throat that is betrayed by the tears, which reveal the hurt and the grief, a kind of hurt and grief that we will never know and can never share because we do not share the bond that truly makes these men brothers.

These men lost a brother.

Not a saint; a brother. A brother who's entitled to a special place in heaven, and today—especially today—woe unto anyone who would say otherwise.

December 28, 2000

RED'S FLYING SAUCER

I'm a big believer in that whole John Donne "No man is an island" thing. When I say that, I'm showing off my expensive liberal arts education, yes, but more importantly, I truly believe that when we lose people of great character, as a community, we are diminished in a very real way.

In recent weeks, we in Manchester have lost some special people.

I'm thinking of the always-elegant Sue Wieczorek, golfing great Warren Tibbetts, longtime library director John Hallahan and old-school deputy fire chief Pete DeNutte to name a few, but today, in this space, in keeping with the John Donne allusion, the bell tolls for Arthur "Red" Ullrich.

He died about a month ago at the age of eighty-seven.

If you're a Manchester native of a certain age, you either knew Red or you knew of him. Thanks to the omnipresent silver canteen truck known as "Red's Flying Saucer," the man was as much a part of life here in the city as the Amoskeag Dam and the Merrimack River.

"But before he had the 'Flying Saucer,' he used to have a Coca-Cola ice chest he'd take around to the parks to sell soda," said his nephew, Richard "Chuck" Ullrich. "Then he got this wooden trailer he called the 'snack bar,' and he rigged it with some gas burners and towed it around to places like Wolfe Park so he could sell hot dogs."

"It was enough for him to make a living," Chuck added, "and then he decided to buy a truck, an F-250 Ford, and he called it the 'Flying Saucer.'"

If I close my eyes, I can still see the "Flying Saucer" standing in the north corner of the Beech Street end zone at Gill Stadium, which was known as Athletic Field in Red's heyday.

Other folks remember it from other places.

"Once he had the truck, he used it to make morning runs to various business establishments around town," said his stepson, Ernest "Buzz"

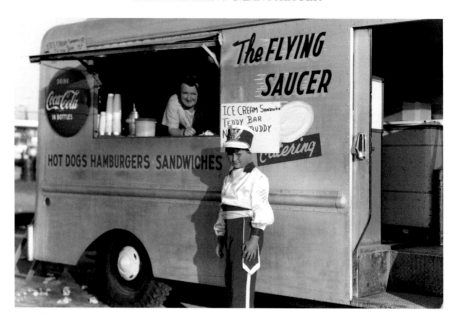

If you're of a certain age, you'll never forget the sight of "Red's Flying Saucer"—with proprietor Red Ullrich at the ready—in the Beech Street end zone at Athletic Field. *Courtesy of the Ullrich family.*

Morey, citing Manchester institutions such as Sharkey's Tires, Schonland's Hot Dogs and Swanson Tool and Die. "He'd be up at four in the morning, doing his prep and making his sandwiches."

He made them right in his home at 193 Thornton Street, which was two doors up from my parents' Sullivan Street home on the West Side. We always knew when Red's morning run was over, because the unmistakable aroma of coffee would waft all over the neighborhood as he scrubbed down the "Flying Saucer" and prepared for his second shift.

Even by 1960s standards, the "Flying Saucer" was a marvel of engineering efficiency—countless drawers and compartments, all put to good use—and Red made certain that every stainless steel surface was gleaming, inside and out.

If we were lucky, Red—with his ever-present cigar jammed into the corner of his mouth—would have some day-old doughnuts left over. If so, he'd dole them out to the ragtag neighborhood posse, that being me, my brother Mike, Albie Van Den Bergh and Red's nephews, Ron and Neil Ullrich.

"And once things were cleaned up, he was off again," Chuck Ullrich said.

Towering Titans and Unsung Heroes

In the summer, he'd run the concession stand at Nutt's Pond in the afternoon, then head to the concession at Athletic Field for night-time baseball.

During football season, he'd have the "Flying Saucer" in the end zone, and when winter came, he had the concession for the skaters at Dorr's Pond, and don't forget, he still did all of his morning routes year-round.

I went with him on the route many times, and you really had to hustle because the employees had maybe ten minutes for their coffee breaks. You had to be there and you had to be there on time, and Red always was.

"He was a very hardworking guy," Chuck added, somewhat needlessly.

The man did know how to have fun, however. He loved to fish, and his annual treks to Pittsburgh allowed him to catch trout and scout for moose, often with Chuck or Buzz in tow. Closer to home, Red played the trumpet, guitar, harmonica and the accordion, the latter putting him in regular contact with the fabulous Donati Quintet, to which I shall return in a moment.

This is a moment Red resisted. From the very day I started doing this column, I asked Red if I could do a piece on him. He was always polite—he'd always suggest that I do a story about the Donati family instead—but he always declined.

"And, as you might well imagine, my Gramp had requested no calling hours, no funeral, no service, nothing to remember or celebrate his life," said his grandson, Scott Bilodeau, who used to deliver the newspaper to my folks.

"He never wanted anything from anyone and never looked for any 'credit' above a man's mutual respect," Scott added.

He had mine. So Red, wherever you are, I hope you'll forgive me for writing this posthumous tribute, and to make things even, if they'll let me, I promise to do that piece on the Donati Quintet.

Meanwhile, as we all try to do our part, of Red Ullrich it can truly be said that he served the people of Manchester.

July 21, 2008

THE LAST BOY IN BLUE

G iven the annual hoopla surrounding Independence Day, you can understand why the anniversary of the Battle of Gettysburg—it ran from July 1 through July 3 in 1863—might go unnoticed by all but a handful of Civil War scholars.

And maybe, just maybe, by those who remember James Marion Lurvey.

Lurvey was the last survivor of Gettysburg. He was there as a drummer boy attached to the Union Army of the Potomac, and when he died in 1950 at the age of 102, he had outlived every one of New Hampshire's 33,937 Civil War veterans.

He's buried in Londonderry, just down the road from the home in the Goffe's Falls area of Manchester where he spent the last sixty years of his life.

The most important year of that life, however, was 1863.

The events of that year—more specifically, James Lurvey's role in those events—have long consumed Jay S. Hoar, a professor of English at the University of Maine at Farmington. He has invested forty years of research into the Civil War service of New Hampshire's "Last Boy in Blue."

"It's ruled my life," Professor Hoar said of Lurvey's story. "I was sixteen years old when I met him. It was 1949. I'd never been away from home, but when I saw his picture in *Life* magazine, I knew I had to meet him."

Hoar hitched a ride from his Maine home to Plymouth, New Hampshire, and then hopped a train to Manchester. After a night in the Floyd Hotel—"It was three dollars a night," he said—he took a city bus to James Lurvey's home at 2915 Brown Avenue.

The details of Hoar's visit make for a story unto themselves, but the story that Lurvey told Hoar qualifies as pure Americana.

James Lurvey was just fourteen years old when he enlisted in the Union army. His mother allowed it simply because he was going to serve with his father, Lieutenant James T. Lurvey, then thirty-six, who was commander of Company A of the Fortieth Massachusetts.

"I remember Grampa once told me that when people asked why he wanted to join the fighting, he said 'For the Negroes,'" his granddaughter recalled. "Then he went on to explain that he had never seen a Negro."

The frail boy hadn't seen much at all, really. Certainly nothing that could prepare him for the horrors he was to witness.

Hoar's research found both father and son at Dumfries, Virginia, in December 1862, when Confederate general J.E.B. Stuart tried to disrupt Union supply lines. While his father went on to further battle at the Siege of Suffolk in April and May 1863, young James—weak and sickly—went on to Campbell Hospital in Washington.

"It was mainly so he could gain strength and return to duty," Hoar said.

When young James was released from the so-called Invalid Corps, he was ordered north to Pennsylvania, where, in Hoar's words, "the Confederate invasion promised an impending battle of unknown magnitude."

At Gettysburg, that battle was joined on July 1. Young James did not arrive until the next day.

"But July 3—and very probably July 4—if he could have eliminated any two days of the 37,554 that he lived, surely they would have been these," Hoar said.

These are some of Lurvey's recollections:

> I never fired a shot. At Gettysburg, I was still a drummer boy [but] during much of that battle I served in the Medical Corps. Shot and shell and the screams of dying men and boys filled the humid air. A non-com told me to put away my drum. He tied a red rag around my left arm and told me I was now in the Medical Corps.
>
> I told him I was not big enough to lift my end of a stretcher, so he assigned me to a field tent. It was stifling inside. I thought I'd keel over when they told me my assignment. Wish then I could have hefted a stretcher.
>
> I was to stand by and carry out the soldiers' arms and legs as the doctor amputated them. I guess that was the day I grew up and left boyhood forever. And I wasn't yet sixteen.

His daughter, Cora (Lurvey) Smith, died in Londonderry ten years ago at the age of one hundred, but she, too, was fascinated by her father's stories of Gettysburg.

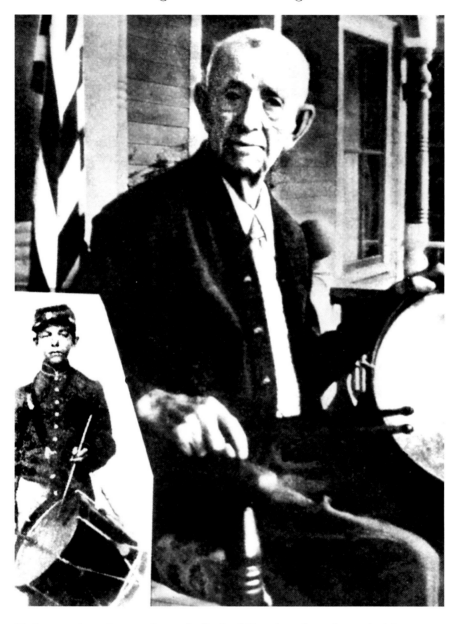

Having served as a drummer boy at the Battle of Gettysburg, James Lurvey had the distinction of being New Hampshire's "Last Boy in Blue" when he died in 1950. *Courtesy of Jay S. Hoar.*

I recall his saying that one hot day, he crawled into a pup tent in the shade and went to sleep. Soon after, someone pulled him out by the feet and told him a soldier had just died of smallpox in that tent. Luckily, he didn't contract it.

He said many times when crossing a river or pond, some big strong soldier would take him across on his back. Many times, water to drink was scarce, and after a rain, the men were glad to drink from pools made by cavalry hooves.

It's hard to gauge the aftereffects of such psychological trauma on a boy, but three months later, young James was discharged at Portsmouth. The documents state: "By reason of youth; age fifteen; not robust."

"During the next ten months," Hoar said, "he recuperated, added stature and strength and decided to try and improve on what he may have felt was an unimpressive military record."

To do so, he reenlisted. It was during this second tour of duty, while at Monson Hill Camp near Falls Church, Virginia, that he first set eyes on the man whose integrity had called him to duty.

"He used to visit us in camp," young James said of President Abraham Lincoln. "He was no great sight—tall and awkward—but he had a great mind. He used to talk with us for the sake of cheering us up, I think."

Two months after Robert E. Lee's surrender at Appomattox, Lurvey was discharged from the Union army. After working in the mica mines and traveling the world on a merchant marine clipper ship, he fell in love with schoolteacher Sarah McConnell of Haverhill, New Hampshire. They married in 1874.

Raising four daughters in Goffe's Falls should have provided his remaining years with all the excitement he needed, but the legend of James M. Lurvey was not yet complete. In 1902, that legend took on even more mythical proportions when, at the age of fifty-five, he was accused of robbing an American Express payroll—like Butch Cassidy—from the Goffe's Falls train station, payroll that was bound for the local Devonshire Mill.

Although he constantly proclaimed his innocence, he was convicted. The jury asked for leniency, citing his war record, but he was sentenced to serve six to ten years in prison. When he was released, he seemed none the worse for the wear. He even managed to attend the fiftieth anniversary gathering at Gettysburg in 1913.

To this day, neighborhood children like Esther (Dancause) Theodore remember him well.

"We all knew who he was, that he had been in the Civil War," she said. "I can still remember walking to school in the morning. He'd be sitting on the porch and he'd always wave to us."

He did that until well past his one hundredth birthday. He told friends that one of his proudest possessions was the congratulatory letter he had received from President Harry S Truman on that special occasion.

And as to the cause of his longevity?

Well, Lurvey always attributed that to his sturdy ancestors and his "fortified" breakfast, a daily dose of coffee spiked with a shot of brandy that he called his morning "oh be joyful."

That formula worked until June 1949, when—two months after his wife had passed away—his daughter Gladys Lurvey reluctantly moved him into the Bedford (Massachusetts) Veterans Hospital.

"Gettysburg was tough," he told Hoar, "but old age is even worse. I'm older now than I ever wished to be. Nobody realizes old age is a hard life till they get there."

That hard life ended on September 17, 1950, but thanks to Professor Jay Hoar, the legend of New Hampshire's "Last Boy in Blue" still lives on.

July 3, 1998

101 Angels of Song

Remember the Singing Nun?

If you were alive in 1963 and came within ten miles of a transistor radio, then surely you must remember the Belgian nun in the Dominican habit, whose cloying hit song—later to become the basis of a major motion picture starring Debbie Reynolds—managed to save western civilization in that it kept an allegedly decadent song by the Kingsmen ("Louie Louie") from topping the charts.

Her song was called "Dominique," and as I recall, that was not only the title of the song, it was also the entire lyrical content, which means it went like this: "Dominique-a-nique-a-nique-a-nique-a-nique…"

And so on. And so on.

Anyway, there are people in the extremely hip recording industry who would have you believe that the Singing Nun was the only nun to make her mark in music, but clearly those people must have been taking some extremely hip drugs because they do not remember Manchester's own 101 Angels of Song.

That was the name of an actual all-female choir—yes, there were 101 members—composed entirely of Catholic nuns from the Sisters of the Holy Cross and of the Seven Dolors, most of whom were affiliated with Notre Dame College.

It started with the late Sister Mary Cecilia. The Pembroke native was a prodigy from a musical family whose gifts flowered further within the convent, which she joined at the age of sixteen. When she ultimately came to teach at Notre Dame, she did so with a doctoral degree in music from the University of Montreal and a plan to help the new college grow and expand.

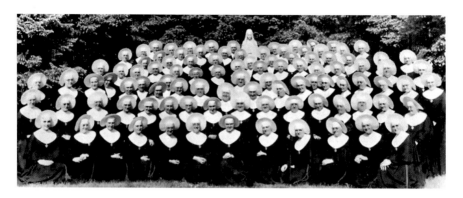

If the group from Notre Dame College was going to be called 101 Angels of Song, promoter Jim Psarakis insisted that there be 101 nuns in the photo on the album cover.

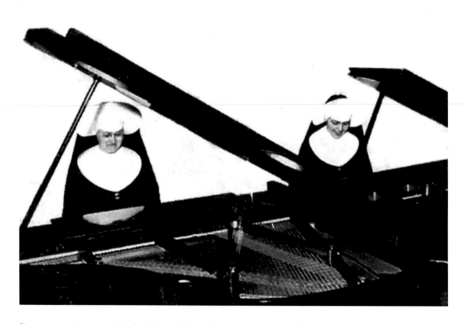

Room was also set aside for Sisters Mary Jacinta and Anita Marchessault, who recorded *First Angel Piano Duet Play the Classics. Courtesy of the Sisters of the Holy Cross.*

Towering Titans and Unsung Heroes

She soon formed a band. It was a band of sisters who came together in the late 1950s and began staging choral concerts. Proceeds were earmarked for the expansion of the campus on North Elm Street, with an eye toward creating a performing arts center.

While they were wowing audiences with local concerts, they won a convert in one Louis DesRuisseaux. He was a part-time faculty member at the college, but he was also the promotions director for the *New Hampshire Sunday News*, and he knew he had something worth promoting.

For a long time, he was the only guy who felt that way.

"I spent a highly frustrating two years trying to get someone in the record business to listen," he told *Sunday News* reporter Linnea Staples, who noted that the typical response to DesRuisseaux's plea was "What can nuns in a convent do?"

James Psarakis felt the same way. He was known as Jim Parks back then, and as the *Union Leader*'s record critic, he knew his way around the recording business, and he thought that Lou DesRuisseaux was simply giving him the business with this stuff about singing nuns.

"In a polite way, I kept putting Mr. DesRuisseaux off," Jim told Michael Hanu, who produced a segment on the sisters that aired on radio stations all over the free world via *Voice of America*. "This went on for quite some time. Finally, after Mr. DesRuisseaux got to me—oh, I'd say about two hundred or three hundred times—I decided I would go up and hear the sisters sing."

Jim laughs about his reticence today.

"Lou told me they were rehearsing at St. Cecilia's Hall over by St. Augustine," Jim explained. "He offered to come along, but I said I'd rather go alone. I was just going to stand outside the door. I figured I'd be listening to a bunch of hens."

He figured wrong.

"I stood outside the door," he said, "and it was the first time in my life I ever heard four-part harmony sung with perfect pitch."

Jim's marketing instincts kicked into high gear.

I met with Sister Cecilia, and I told her I'd like to do something with them, but it had to be done my way. She said, "How much?" I told her, "It won't cost a dime."

There were only thirty-six of them back then, so I said, "Do you have 101 singers?" She said, "Why 101?" I told her it was an odd number, something we could promote. I had been working with a band called 101 Strings, and they were doing fantastic for our company, so I figured we'd do 101 nuns and call them 101 Angels of Song.

Before long, Sister Cecilia met Jim's quota and then the sisters—he dubbed them "the black-habited songsters"—gathered for photographer S.J. Chaloge.

"I told Sister Cecilia I had to count them," Jim said. "Sure enough, with her, there were 101. You have to count them because if you say there's 101 and people see the picture, they're going to count them. If they count 100, you're dead. If they count 101, they believe in you."

And by this time, Jim believed in them enough to approach record labels on their behalf, but remember, it was 1961—long before anyone ever heard of the Singing Nun—and it was a tough sell.

"I couldn't get in the front door," he said. "People thought it was religious, and religious recording houses were few and far between. Our stuff wasn't really religious. It would fit into the classical end, especially the piano playing. You should hear it. Man, it would knock your socks off."

In time, it would knock Ferrante and Teicher off the Billboard charts, but we're getting a little bit ahead of ourselves. What Jim finally did was start an American record label for the sisters. He called it Marveltone, and it was wholly owned by the sisters. He even registered their names with trade associations like BMI and ASCAP to protect their copyrights and to ensure proper payment of royalties.

Jim's persistence ultimately paid off when an Australian firm, W&G Record Processing Co., agreed to produce and record an album. It was quite a trick, especially when you consider that Jim—who is Greek Orthodox—was working for Seventh Day Adventists on behalf of Catholic nuns.

"We did twenty thousand LPs right away," he said. "In 1961, that's a lot of LPs. That's like a million today. Then we released them in Canada, plus England, plus France, plus Germany, plus here."

Did they sell? Did they ever.

That first album—*Introducing 101 Angels of Song*—was so successful that it spawned a follow-up called *101 Angels of Song in Concert*. That sold even better than the first. That led to an instrumental album called *First Angel Piano Duet Play the Classics*, which highlighted the abilities of Sisters Mary Jacinta and Mary Neree, who is known as Sister Anita Marchessault to her students at the college today.

"Eventually, we sold all of the records," said Sister Anita, who is now eighty-three. "At the time, I think we could have sold them for $20.00 each. I think we probably sold them for $5.95, but in those days, $5.95 was a lot of money."

"We did five LPs in all," Jim said. "The last one was never released because Sister Cecilia died. It was going to be *101 Angels Sing the Pops*. I had the covers

made for it, and we had recorded several takes, but when she died, I stopped it all."

The recording may have stopped, but the legacy of the 101 Angels of Song is very much alive at Notre Dame College. It lives on in the structure known as Holy Cross Hall—an edifice truly built on song—where their music will echo through the ages.

Almost as long as "Dominique" will ring in your ears.

February 18, 2002

THE MILLYARD MAN

Manchester-Boston Regional Airport is a boon to this city for many reasons.

Yes, it provides a convenient alternative to Logan Airport—I sound like a commercial, don't I?—and yes, it serves as a great economic engine for the city, but another reason I like the airport is because, in its earlier incarnation as Grenier Field, it brought some great people to Manchester.

Consider Joe Nelson.

Back in September 1945, Joe was a second lieutenant in the Army Air Corps. With World War II coming to an abrupt end, the Bronx native drew a really glamorous posting—he found himself in an office on Silver Street in Manchester working for the North Atlantic Division of the Air Transport Command—and with that posting came a bunk in the barracks at Grenier Field.

For those of us who love Manchester's Millyard, it was serendipity. No one could have known it back in 1945, but Joe Nelson's brief posting to Manchester would result in a promise that would bring him back here many years later.

See, Joe fell in love with a pretty switchboard operator here in town—the former Ruth Ball (Central High class of '38) from Lake Avenue—and when Ruth agreed to marry Joe and follow him to New York, where an engineering job awaited him, Joe vowed that, one day, he would bring her back to her hometown.

And again, for those of us who love the Millyard, it was serendipity.

Joe and Ruth didn't come back to Manchester until 1968, but when they did, it was just in time for Joe to take the job as director of the Amoskeag Millyard Redevelopment Project.

He's ninety-three now—"I'll be ninety-four in six weeks," he pointed out, "so you might as well say I'm ninety-four"—and since the Millyard provided the quintessential Queen City backdrop for thousands of TV cameras during the most recent presidential primary, I figured it was a good time to say thanks to Joe.

He came back here at a pivotal time.

For years, the Millyard had festered. It was an overcrowded, undermaintained complex that had suffered from benign neglect for more than thirty years. Many building owners were unwilling or unable to pay for much-needed upkeep—let alone improvements—and for those of us who call this place home, there was that constant negative vibe, a lingering animosity "by Manchesterites who [were] still bitter about the abrupt liquidation of the Amoskeag Manufacturing Corporation," according to *Time* magazine.

Yes, when it came to the Millyard, people in Manchester were divided into two camps.

The Manchester Housing Authority, which was assigned to oversee America's first "Urban Renewal Project of Industrial Rehabilitation," went so far as to acknowledge that divide.

"Those critical of city policy favor two very different solutions," the MHA reported. "One [group] desires the preservation of the Millyard in its present form due to its great architectural and historic value, while the other group, in contrast, supports the total destruction of all mill buildings."

King Solomon couldn't have found middle ground with that crowd. But Joe Nelson helped pull it off.

It took twelve years of his life—and more than $28 million in federal funding—and he did it for less money than you'd pay for a decent used car these days.

> Counting the time before I went into the service, I had been working in New York for thirty-two years. I had worked on the Queens-Midtown Tunnel and the Brooklyn Battery Tunnel and when they passed the Housing Act in 1949, I was the administrator for all of the Slum Clearance/Urban Renewal projects in Manhattan for Robert Moses.
>
> At one time, we had twenty-seven projects going, and my claim to fame is that, when we came up with another project north of Columbus Circle, I came up with the name for Lincoln Square.

He makes that claim modestly, and modest is the word for his first salary request in 1968.

Towering Titans and Unsung Heroes

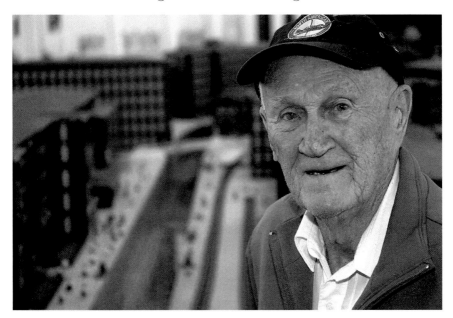

For those of us who love the Amoskeag Millyard and its lasting place in the history of Manchester, Joe Nelson truly looms as a giant. *Courtesy of Tom Roy/*Union Leader.

"Before we moved here, we came up on vacation and my brother-in-law said I should call Romie Dorval with the Housing Authority," Joe said. "They were looking for a project manager for the Amoskeag Millyard, so I had this interview."

> *They asked me what my salary was, and when I told them it was seventeen thousand dollars a year, it was "Oh, no! We can't afford that!" The offer was for thirteen thousand a year.*
>
> *Thirteen thousand? I was fifty-four years old and we had five kids, but I had a pension coming from New York, so I figured I could swing it. I told them I'd take the job for thirteen grand, but if they hired anybody who was making more, I had to get the same thing.*

Oh, the things he did.

From his first day on the job, there were thirty-five properties to be acquired, and landlords balked. A total of sixty-one companies were to be affected, and owners squawked.

There were stagnant canals to be filled and sewerage tunnels to be drilled. Yes, some structures had to come down—consider the curveball that came his way when they found anthrax in the Arms Textile Mill—but there were

other buildings to be saved and roadways to be paved, and Joe gave as good as he got in his dealings with the intractable B&M Railroad.

Joe would be the first one to tell you that didn't take on Goliath by himself—my predecessor Maurice McQuillen called the project "Manchester's most ambitious and costly federally financed urban renewal project ever"—but I'll bet Joe still has a slingshot in his pocket.

We were looking at a pocket-sized version of the Millyard recently.

We were at the SEE Science Center at 200 Bedford Street—don't even think about asking Joe for his take on the building's ultramodern glass and steel façade—and we were looking at the spectacular scale-model Lego recreation of the Millyard.

My colleague, Tom Roy, was taking pictures for this piece. He was shooting Joe with the miniature Millyard in the background, and it occurred to me that the setting made Joe look like a giant.

And then it struck me. For those of us who love the Millyard, Joe Nelson is a giant.

January 21, 2008

THE FLAG RAISER

A few months ago, I was asked to speak at a breakfast for the Drug Abuse Resistance Education (DARE) program that's designed to keep kids off drugs, so I wrote a speech about how kids need heroes and role models. It seemed appropriate.

I figured I could talk about some people I admire, local folks who overcame some hurdles to make their marks in the world. A lot of the names are probably familiar to you. Some are famous—like Richard McDonald and Grace Metalious; some not-so-famous—like Clyde Joy and Joe Maltais. But to me, they're what hometown heroes are all about.

The speech went over well enough, I guess. People laughed when they were supposed to laugh, and they applauded when it was time. Looking back on it, I realized I only made one mistake.

I forgot Rene Gagnon.

We do that a lot around here. His image is frozen in the memory of every American who was alive in 1945, and for those of us who've come along since, he's part of an indelible national symbol; yet somehow, we often forget to claim him as one of our own.

That won't happen anymore.

At two o'clock this afternoon, the Memorial Day parade will step off on Elm Street, and by three o'clock, it's expected to wind its way to Victory Park. That's where they're going to unveil a monument to Rene Gagnon. After fifty years, he's finally getting some recognition where it matters most—in his hometown.

It's a symbolic gesture, to be sure—Rene died in 1979—but he learned the value of symbols on February 23, 1945. That was the day when he joined with four other U.S. Marines and a U.S. Navy corpsman and helped plant a flag in a volcanic ash heap called Mount Suribachi on the island of Iwo Jima.

Like all combat soldiers, these six were striving toward a common goal, but not with weapons of war. They were armed instead with the most powerful symbol of all—a flag—and the unforgettable image captured by Associated Press photographer Joe Rosenthal made them symbols unto themselves.

The only problem? No one knew who they were.

Rosenthal had taken a series of photos that day and dispatched his film without ever seeing the finished product. When the photo began running on front pages all over America—it showed up in the *Manchester Leader* on February 26—everyone wanted to know their names.

War has little patience, however, for the vagaries of public relations, and as if to punctuate the savagery of the fighting on Iwo Jima, three of the six were dead within a week of the flag raising.

Mindful of morale on the homefront, military officials tracked down the survivors—a Pima Indian from Arizona named Ira Hayes, U.S. Navy pharmacist's mate John Bradley from Appleton, Wisconsin, and Manchester's own Rene Gagnon—and immediately ordered them stateside.

Even in a more innocent media age, Rene made great copy. He was right out of Queen City central casting—a French Canadian kid who had to leave Central High School after two years to work in the mills.

He tried to join the U.S. Navy at seventeen but was refused for high blood pressure. When he finally got into the U.S. Marine Corps, he kept a picture of his sweetheart—Pauline Harnois—in his helmet, and on the way home, he told reporters that he couldn't wait to taste his mom's cooking again.

The reason for his homecoming wasn't entirely sentimental. Along with Hayes and Bradley, he was sent on a barnstorming tour of America. Thanks in part to the star power of the surviving Iwo Jima flag raisers, the Seventh War Bond Drive raised $220 million for the war effort.

By August 1945, the media crush began to subside. Shortly after V-J Day, Rene was back in the Pacific in combat fatigues, serving with U.S. occupational forces in China. After his discharge in 1946, he was back home with Pauline—America had dubbed her "the sweetheart of Iwo Jima"—and he was back in the spinning room at Chicopee Manufacturing. He couldn't have been further away from the spotlight.

And in a way, he couldn't have been happier.

"To tell you the truth, he was uncomfortable about all that hero stuff," said Omer Gagnon—a childhood friend from St. George's School and the Millyard neighborhood known as "the Corporation"—who saw plenty of action himself at Omaha Beach and Salerno. "The way we saw it, the only hero was a dead hero. They're the ones who gave their lives for their country."

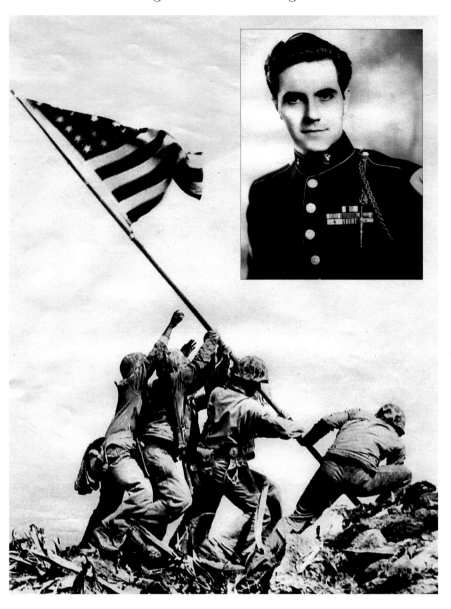

He is part of an image that is burned into the consciousness of every American, and yet here in his hometown we sometimes forget about Rene Gagnon. *Courtesy of Joe Rosenthal/ Associated Press; Inset courtesy of Pauline Gagnon.*

Attention still came Rene's way—there was even a cameo role in the John Wayne film *Sands of Iwo Jima*—yet there were subtle twists of fate, strange mergers of chance and coincidence that seemingly conspired against him.

In the historic photo itself, Rene is largely obscured by the figure of John Bradley, and it wasn't the last time that he would be denied his moment in the sun.

Even in the history books, his legacy is frequently garbled. In *Iwo Jima: Legacy of Valor*, for instance, author Bill D. Ross describes Rene as being from "New Hampshire's Green Mountains."

But most importantly, it was when his moment of glory was at hand in his hometown that the fates intervened most cruelly.

When the U.S. Marine Corps ordered him home in April 1945, the Queen City was in a frenzy. The reception planned in his honor was described as "the biggest homecoming welcome in the history of Manchester." There was to be a parade down Elm Street, a banquet at the Carpenter Hotel and a massive gathering at Bronstein Park. Dignitaries throughout New Hampshire were clamoring to share the stage with Rene Gagnon. Legionnaires and Cub Scouts alike were lobbying for spots in the parade, and for a solid week, the newspaper whipped the city into a patriotic lather. Just when it seemed like his day would never come, it arrived at last.

It was April 12, 1945. And Franklin Delano Roosevelt had died.

The crowds that had lined Elm Street waiting to cheer Rene Gagnon stood in stunned silence as police cars with bullhorns broadcast the tragic news. The celebration was canceled. Before it began, Rene's party was over.

Only now, some fifty years later, is he getting his due.

Maybe he would have preferred it that way. After all, he once told a reporter that "I'd rather face another invasion operation than go on the bond tour," but in his absence, people like Hubie McDonough Jr., Don Duhamel, Mike Lopez and Ray Caron have made certain that future generations will know of his special place in American history.

For the record, Rene Gagnon is buried in Arlington National Cemetery. His body lies in Section 51, Grave 543—just one more headstone in a sea of 181,000 identical white markers—but as of today, he will be remembered in Manchester forever thanks to the monument in Victory Park that stands, fittingly enough, in the shadow of the American flag.

May 29, 1995

A Short Story

Did you know that there is an actual group in America known as the National Association of Short Adults?

It even has its own motto: "Hey you, down in front!"

Okay, I'm joking about the motto, but I'm serious about the association. For some reason, it popped into my mind when I was flipping through the paper recently and saw the alarming conclusion of a study published by *American Demographics* magazine.

The conclusion: "The Average American Man Is Shrinking."

Speaking as an Average American Man, I was not happy about this fact, mostly because I recently purchased a snappy, double-breasted blue blazer, and if I'm shrinking, I may have to spring for alterations.

That's why I decided to check with the Bureau of Vital Statistics. Actually, it's not a Bureau of Vital Statistics. In technical household terms, it's more of a Doorjamb of Vital Statistics. The doorjamb in question is in the kitchen at my parents' house, where, throughout my entire life, my folks have clinically documented my height via the highly scientific pencil-mark-over-the-head method.

I am happy to report that I am still five foot ten in my stocking feet, as long as I wear five pairs of socks.

Which I do. I always do.

I like being five foot ten. It's a guy thing. You know how some women supposedly lie about their age? Well, men lie about their height. All of them. Every single one. It starts at birth. A guy who grows up to be six feet tall will say he's six foot one. A guy who's six foot one will say he's six foot two, and so on and so on. And it's worse with shorter guys.

In Manchester, he was George Washington Morrison Nutt, but when the little man signed on with P.T. Barnum—who paired him with Minnie Warren—he became known as Commodore Nutt. *Courtesy of Weber and Mahn Photo/Manchester Historic Association.*

Towering Titans and Unsung Heroes

With shorter guys, there's usually a two-inch differential between fact and fantasy, so a guy who's five foot six will say he's five foot eight, while a guy who's five foot four will say he's five foot six.

This lying-about-your-height thing is an immutable law in the guy world. Some guys lie on their tax returns and most guys lie about their golf scores, but all guys lie about their height.

As far as I know, there's only been one exception: George Washington Morrison Nutt.

In case the name doesn't ring a bell, maybe you'd recognize the Manchester native by one of his many stage names. Let's see now, there was Commodore Nutt, and the Remarkable Dwarf and the Thirty Thousand Dollar Nutt, and, oh yes, the Shortest Man in the World, as he was labeled by legendary showman P.T. Barnum, who stretched the truth on everything but Nutt's height.

That's a tad ironic.

If any guy had reason to exaggerate his height, it was Little George. Depending on your source, the guy was only thirty-three inches tall, which is two foot nine on the doorjamb scale. Yes, Commodore Nutt was the original little big man, and even today, more than one hundred years after his death, he remains larger than life.

Sorry. Cheap shot. I couldn't resist.

For the record, George Washington Morrison Nutt was born on April 1, 1848, at the juncture of what we now know as Weston Road and South Willow Street.

Little is known of his formative years, except that we know he didn't like to swim in nearby Nutt's Pond—it was named for his family—because he was afraid that the industrial slime and pollutants would stunt his growth. No, wait! That's why I was afraid to swim there! George didn't like to swim there because the pickerel kept chasing him. Honest.

If all of his family members had been normal-sized people, George might have felt like an outcast, but as fate would have it, one of his brothers stood just forty inches tall. Still, his size was a minor nuisance compared to the fact that his parents, tragically, named his brother "Rodnia."

Since a career in the National Basketball Association was out of the question, George and Rodnia traveled around New England on an informal song-and-dance circuit run by a Manchester man named William Walker. By 1861, the aforementioned P.T. Barnum caught word of the act, and since George was a full two inches shorter than Barnum's headliner—General Tom Thumb—Barnum signed him to a three-year, $30,000 contract, which worked out to $1,400 a pound.

Since Tom Thumb held such an exalted (but phony) military rank, Barnum figured that Little George needed a title, too, and since Lionel Richie wasn't born until 1950, George became the first Commodore in show business.

Next, Barnum brought a little sex appeal to the act. Very little. About thirty inches' worth. That was the height of Lavinia and Minnie Warren, the female dwarfs who joined Barnum's show. Since Lavinia was one of the few women with whom he could truly see eye to eye, Little George tried to court her, but sadly, she spurned the Commodore's overtures and married Tom Thumb.

It figures. The tall guy always gets the girl.

Luckily, the Commodore bounced back, and because of his fame, he was able to rub shoulders with the high and mighty, like Pope Pius IX, Napoleon III and a lot of other guys named after Roman numerals.

For instance, there was the time that he met Abraham Lincoln (this is true), who, you may recall, once said that a man's legs only needed to be "long enough to reach the ground" (this is also true), a remark that prompted the Commodore to punch the president in the kneecap (this is not true).

Then there was his meeting with Britain's Queen Victoria (this is true), which so enchanted the monarch that she gave the Commodore a miniature coach and four tiny ponies (this is also true), as well as a vigorous hug that required him to be freed from her décolletage by the Jaws of Life (this is not true).

Eventually, the Commodore tired of show business and decided to devote the rest of his days to more worthwhile causes, such as gambling, drinking and womanizing.

At one high-society costume ball, for instance, the *New York Star* reported that the Commodore got lost several times, "only to be discovered hiding inside the trains of some lady masqueraders." That kind of behavior, while admirable, probably contributed to his death at the tender age of thirty-three in 1881, although I like to think he died a happy man.

It's unfortunate that I'm so busy these days, because after researching the history of Commodore Nutt—whose inconspicuous tomb is located in the Merrill Graveyard near South Willow Street and Huse Road—I'm convinced that his story would make a fine novel.

Think a short story would be okay instead?

April 19, 1993

No Man Is Richer

George Fortunato retired on Friday. It didn't make the business page, but then again, retiring dishwashers seldom get much in the way of media coverage.

Today, at least for this one day, George is going to be the exception.

See, in the restaurant business, it's a given that the typical dishwasher's career will be measured not in years but in hours. Once again, George is the exception, and so, after thirty-four years of faithful service in some of Manchester's busiest restaurant kitchens, we're going to celebrate the end of a remarkable career.

The career is remarkable because George is remarkable. And so are his friends.

If they had a mind to, those same friends could probably come up with the precise clinical term that would describe George's minor developmental disability, but they've never bothered to find out what it is. They don't plan to either.

"When you find out what a sweetheart he is, you don't need to know," said one of those friends, Ann (Fisher) Webster, who first met George when she was a thirteen-year-old busboy—make that busgirl—at The 88 Restaurant. That was thirty years ago.

"He's just an innocent," she said. "Sometimes we compare him to Forrest Gump, but it isn't meant to be demeaning. He just has that same innocence, that same childlike sense of wonder, and he'll do anything for anybody."

But when you ask him to do something, it's best to be as concise as possible. A few of his employers have learned that lesson the hard way. There were no hard feelings, though, even when he inadvertently helped a couple of unscrupulous managers load their truck under cover of darkness so they could make off with most of the banquet gear from Giovanni's Restaurant.

"I went to work the next day and the boss says, 'We got robbed,'" George explained. "He said they took everything out of the cellar. I told him I helped. They were my bosses. They asked me to help and I did. I had always worked for my father, and he taught me to do what the boss said."

Thanks to George, the equipment was recovered that day.

Generally, George's verbatim obedience has produced more positive results. At other times, those results have been far more amusing, too, particularly during his early days at The 88. He was twenty-eight when he started working there.

"Things were getting a little tight at home, and I figured it was time to go out and support my father and my sister," he explained. His eagerness knew no bounds.

"They hired me to wash dishes and bus tables and put away the stock and clean up around the building," he said in his rapid-fire delivery.

> On Thursdays, we used to have a United Nations Buffet Day, and we had seven flags we'd put up on the roof so people would know, and sometimes they let me put up the flags.
>
> My boss bought this expensive ladder with an extension so we could put up the flags, and he always told me he didn't want it left outside to get stolen so if I saw the ladder outside, I was supposed to bring it in.

One day, George saw the ladder outside. He brought it in.

A little while later, he went to the restroom on the second floor.

"I could hear all this yelling and hollering and swearing, so I opened the little bathroom window and there was my boss [longtime 88 kitchen manager Salvatore Coco] right there on the roof. I didn't realize it was Thursday. He was putting up the flags when I put the ladder away, so I said, 'You told me if I ever saw the ladder outside to put it away, so I did.'"

"I stayed away from him the rest of the morning," George explained, "but he laughed about it later."

And then there was another manager at The 88 who told George to take two bags of cement and "put them in the toilet downstairs." You can probably deduce the outcome on your own—Roto-Rooter was involved—and you can rest assured that a manager, like Salvatore, soon came to issue his commands with great precision.

Charlie Wienberg laughed as George recalled the stories.

After twelve years at The 88 and its subsequent incarnations, George went to work at the Memory Lane restaurant in the Mall of New Hampshire in 1977. A few months later, Charlie became his boss. They've

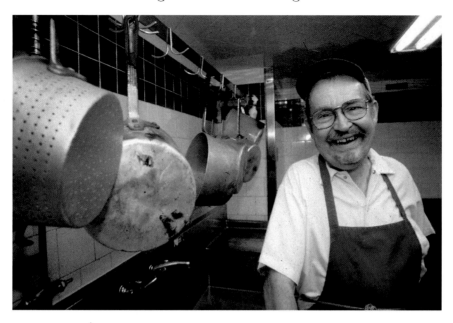

When it was time for George Fortunato to retire from his dishwashing career, he didn't need a gold watch. His friends are more precious than gold. *Courtesy of Bob LaPree/*Union Leader.

been friends ever since; more than friends, really. Since George's father and sister passed on, people like Charlie and Ann and Linda Jones have been like family to him.

"Anyone who's worked in the restaurant business knows that dishwashers are not the most conscientious people," Charlie said.

> *You put an ad in the paper, you hire someone and two weeks later they quit, and you go through it all over again. Forget about the quality of his work, which is exceptional; with George, you always knew you'd have someone there. It would get crazy in the kitchen and kids would be quitting and walking out and George would still be in there, plugging away. George was the guy.*

Perhaps that's why he was Memory Lane's employee of the year in 1980 and 1981. "I still have the plaques at home," George said. "They're beautiful. I have them on the wall at home. I'll always keep them."

The plaques actually outlasted the restaurant. Memory Lane closed back in 1990—"It was January 30," said George, who has a phenomenal memory for dates—and one of owner John Carroll's primary concerns was the fate of his favorite dishwasher.

"The night before they closed, the manager called and asked me to stop by," Charlie said. "John had left a letter of reference for George and there was a $100 bill in the envelope."

It might have been a scary time for someone in George's circumstance, but then, as always, his friends stepped in. Ann had landed a bartending job at The 99 restaurant just across South Willow Street, and George was on the payroll in no time. That was nine years ago, and on Friday—his last day—his co-workers gathered to raise a glass in his honor. And George is not averse to raising a glass.

"We had an arrangement at Memory Lane," Charlie laughed. "A dishwasher would call in sick, and I'd need George to stay late and he always agreed, so at the end of his shift, I'd send him over to the employees' booth and make sure there was a cold beer waiting for him. All of a sudden you'd hear this 'Oh, boy!'—that's his trademark—and you knew George was a happy guy."

With any luck, he'll be even happier in retirement.

"We put his name on a HUD [Housing and Urban Development] waiting list for an apartment," Charlie said, "and if he gets one, that will cut his rent in half. He has a small pension from The 99, and he'll start drawing Social Security in July…"

"August," George interjected. "August 18."

"He's right," Charlie laughed. "August. And if we can get him a part-time job at Shop 'N Save, he may be better off financially than he is working full time."

Once he gets settled, George will have time for something that means the world to him. He wants to learn to read.

"I know he can do it," Charlie said. "My wife is a teacher, and she said if George were born today, he would certainly be mainstreamed in school. He was never given an education. He was just born in a different time."

And what a time they have in store for him tomorrow night. His friends have organized a surprise retirement party to be held at The Yard restaurant starting at 7:30 p.m. If you want to get more details, you can call Charlie, but please don't mention it to George in the meantime.

If you haven't figured it out already, George Fortunato is a lucky man.

Sure, he could be retiring from some big corporate job where they'd be sending him off with a gold watch and a golden parachute, but he has something more precious than gold.

He has friends. No man is richer.

June 28, 1999

UNCLE GUS

After having weathered the most ferocious tempest ever conjured up by Mother Nature—that being the firestorm generated by twenty-five star-struck, sugar-addled prepubescents—you didn't think a little breeze like Hurricane Andrew was going to faze Uncle Gus, now did you?

Of course not.

Therefore, I am happy to report that Manchester's most famous television personality, Gus Bernier, is alive and well and probably strolling toward the third tee at Key West Resort even as your eyes pass over this paragraph.

He's about 1,800 miles from Manchester now, as the Delta Shuttle flies, but in another sense, he's no further away than the back of your baby boomer brainpan, forever cemented in your psyche if you were weaned on Jiffy Pop, Waleeco Bars and Bonomo Turkish Taffy.

It is an idyllic retirement existence for Uncle Gus and his wife—who I guess we'll have to address as Aunt Doreen—and if you are thinking of dropping by, you'll find them at Mile Marker 23 on U.S. Route 1, somewhere between Key West and Key Largo.

"We live on an island, actually. It's called 'Cudjoe Key,' which sounds pretty exotic, but the word 'Cudjoe' is a corruption of 'Cousin Joe,'" said Gus, now seventy-three, who must shudder at the thought of such atrocious enunciation, considering the crisp diction that marked his radio and television work.

"We were really very fortunate with Hurricane Andrew," he added. "We were supposed to go the other way, toward the mainland, but we evacuated to Key West instead and rode it out at the nineteenth hole on the golf course, which is elevated. If it dropped one degree south, we'd have been wiped out. Instead, all we got was a breeze."

How appropriate.

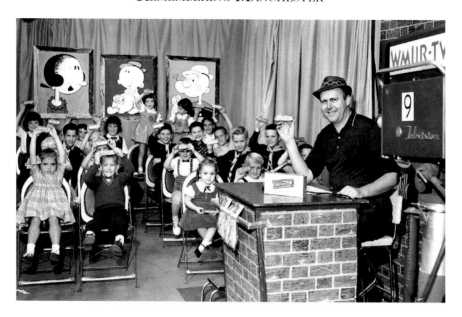

Looking back, *The Uncle Gus Show*—featuring Gus Bernier—was like our version of *Sesame Street* or *Mister Rogers' Neighborhood*, only without the intellectual hoo-ha. Union Leader *File Photo.*

When he was an everyday fixture on WMUR-TV, sitting there in his Banlon shirt and trademark fedora, he made hosting a kiddie cartoon show seem like a breeze, too, and it's hard to believe that a dozen years have passed since the last cry of "So long, Sally" echoed out of the studio at 1819 Elm Street, but more about that trademark sign-off later.

Kermit the Frog wasn't even Kermit the Tadpole when Uncle Gus made his debut back in the waning days of the Eisenhower administration, but looking back, *The Uncle Gus Show* was kind of like our *Sesame Street*—or maybe our *Mister Rogers' Neighborhood*—only without a lot of the intellectual hoo-hah.

Like all Channel 9 productions of that era, *The Uncle Gus Show* only found its way onto the air after months of exhaustive research that included a careful examination of demographic trends, viewer sampling, audience surveys and advertiser demand.

Yeah, right.

"We were running some cartoons on the air one afternoon, and some kids were walking through the studio, so a manager named David O'Shea asked me to put on a funny beanie and entertain the kids, so I did," Gus said.

Later on, they put the camera on me, and I said if any kids wanted to come on down, they could watch in the studio. Well, the next day, a little girl

*came in, and she was staring at me through the plate glass window. She
came back four or five days in a row.*

*Gradually, other kids came, so we started talking to them on the air
between the cartoons. After about a month, there was a flood of them, so we
set up shop to handle about twenty-five kids a day. Within a couple years,
we had a waiting list eighteen months long. It was phenomenal.*

Chalk up another one for surveys, demographics and planning.

Truth be told, the word "planning" doesn't show up a lot in Gus Bernier's
curriculum vitae. He was a drummer in the U.S. Army Air Corps during
World War II, playing United Service Organization (USO) shows with a six-
piece band at hot spots like Goose Bay, Labrador and Meek's Field outside
Reykjavik, Iceland, so you can probably figure out why Manchester looked
so good when he drew duty here in 1943.

After the war ended, he took a job as a clerk at the A&P on Elm Street,
and since it was a short walk up the street to WMUR, he began to hang
around the fledgling radio station hoping to catch some work. He did.

"I was hired as an on-the-job trainee in 1947, doing the early news with
Don Stevens," he said, and before he would leave the station more than thirty
years later, his duties would include news, weather, sports, commercials, a
steady stint as Santa Claus and, of course, *The Uncle Gus Show*.

See what careful planning can do for you?

Actually, it was the seat-of-your-pants atmosphere that gave *The Uncle Gus
Show* its charm, and the little bit of planning that did take place—Gus set up
a carefully arranged seating chart, a trade secret until now—allowed him to
provide each guest a McLuhanesque moment of celebrity.

Uncle Gus may have received top billing, and Popeye, Olive Oyl and
Swee'Pea got their pictures on the wall, but the kids were the stars, a fact that
distinguished *The Uncle Gus Show* from Boston competitors like "Big Brother"
Bob Emery, Frank Avruch's Bozo the Clown, Major Mudd and his marching
ants (remember what IBBY stands for?)—even Rex Trailer and Pablo.

Did those guys have the nerve to officiate live "Boob Tube" races? Did
they challenge their guests to play "Name the States"? Did they risk death
and dismemberment with the "Bean Bag Toss"? And did they incur parental
wrath through the diabolical wiles of "Simon Says"?

"Oh, I used to get letters about Simon Says," he laughed. "Mothers and
fathers would write and call and tell me what a beast I was when I'd catch
the kids at the end. They just thought I was the most cruel man on Earth."

Uncle Gus? Cruel? Okay, if you stepped out of line in the studio, you were
banished to the Black Hole off camera, but well over 100,000 kids made

their TV debut at his side, and I haven't heard any local axe-murderers attribute their madness to defeat at Simon Says.

"We had our share of accidents on the chairs, and the gaffes that come when children speak on live television," said Gus, whose deadpan stare into the camera on such occasions was rivaled only by Johnny Carson, "but I'd be willing to bet the kids enjoyed themselves."

Even the ones who weren't there, like Sally McDonald, a mentally challenged child whose fan letters so touched the host that he ended every show with the salute, "So long, Sally."

But now there's golf to be played, and we're cutting into the man's golden years, so I guess it's time once again to say "so long" to Uncle Gus.

Okay, you with me? All together now: "So long, Uncle Gus."

What's that?

Oh, okay. Simon Says, "So long, Uncle Gus."

September 14, 1992

A Monumental Talent

They're opening a new exhibit at the Currier Museum of Art this summer, and the museum asked some local folks—me included—to help out by choosing their favorite piece and writing a little bit about why it's special to them.

Susan Leidy gave us a long list of pieces from which to choose. I went over it a few times, looking for something that would be appropriate for me. Charles Sheeler's oil painting titled *Amoskeag Canal* would have been easy to justify from a professional point of view, and from a thirsty personal standpoint, Edward Hopper's painting entitled *The Bootleggers* would have worked nicely, but I decided to pass on both.

I'm going with a piece of sculpture, a bronze bust titled *Portrait of Alfred J. Chretien*. It's by Lucien Gosselin.

That's what cinched the deal for me. I figure if I can get people to stop and examine a piece of Lucien Gosselin's work—really look at it—well, then it's worth the effort, because his efforts have brought beauty and majesty to this city for the past seventy years.

His work is all around us. It's at the Currier, yes, but it's also at: Sweeney Park, where his regal bust of Henry J. Sweeney—the first soldier from Manchester to die in World War I—occupies a place of appropriate honor; Mount Calvary Cemetery, where his monument to William H. Jutras—the first Franco-American soldier from Manchester to die in that same war—is, sadly, seen by too few people; Pulaski Park, where his heroic equestrian statue of Polish general Kazimierz Pulaski forms the centerpiece of the park once known as Tremont Common; and Victory Park, where his soaring monument to honor the men of the World War—they didn't number the wars in those days—was his first major commission and his first great work in Manchester. That makes it as good a place as any to begin, and we begin with a short biographical interlude.

Lucien Gosselin was born in Whitefield in 1883 and moved to Manchester two years later. His father was working class—Amoskeag Manufacturing, naturally—but his mother's family was rooted in the arts. Lucrece Gosselin nurtured those roots, and after schooling at St. Augustine and an apprenticeship with local artist Emile Maupas, Lucien was off to Paris.

Among his benefactors? Bishop Georges-Albert Guertin.

In Paris, Lucien won medal after medal, but with the Great War raging to the east, he learned about more than sculpture.

"We see so many wounded men," he said. "The hospitals are full of wounded and soldiers are a common sight. It is terrible. They are often blinded and they present a most helpless spectacle. It is terrible."

It was 1916 when he returned home to Manchester. Andrew Spahr, who is curator at the Currier, is intrigued by that move.

"Often, artists tend to gravitate to larger cities," he said. "That's where they could find commissions and make a living, but he came back to Manchester. It could have been a big fish in a small pond thing, but certainly he did find work."

Did he ever. It started with small medallions and then small bas-reliefs and small busts. He worked in clay and plaster and then cast in bronze. As his subjects grew in scale, so too did his commissions.

"On June 19, 1928, the city council authorized a $34,500 bond issue for the World War monument," the *Manchester Union* reported. "The design submitted by Manchester artist Lucien Gosselin was selected for the memorial."

Paul Du Beau, now eighty-one, watched it take shape.

"His studio was on Lowell Street across from the Coconut Grove," he said. "My cousin was working there, my dad was helping him. It was a family thing, you know, and when they created the first clay model, everyone was involved. The separation of power came when he started carving the clay."

Lucien carved out a masterpiece.

David Ruell, author of *The Public Sculpture of New Hampshire*, has an interesting take on this "fluid, integrated" monument, especially when compared to the circular Civil War monument in Veterans Park.

"The monument, as a whole, proclaims the American triumph," he wrote.

By contrast to this sophisticated design, the Civil War monument—and most of the state's earlier monuments—are rather static and quiet. As the Civil War monument was the largest erected in New Hampshire in the 19th century, so the World War monument was the largest built in the state in

When Manchester's Polish community created the Pulaski Park Memorial Statue
Committee in 1934, it awarded the commission to local sculptor Lucien Gosselin, at right.
Photo courtesy of Priscilla Netsch.

the 20th century. Manchester was fortunate to again find a sculptor equal to the task.

As his own taskmaster, Lucien pressed on, and the Depression did little to hinder his work. In fact, it may have helped. When the city's Polish community created the Pulaski Park Memorial Statue Committee in 1934, they awarded the commission to Lucien Gosselin.

His salary came courtesy of the Federal Arts Project of the Works Progress Administration. His model came cheap.

"It was my father," said Priscilla (Gosselin) Netsch, who is the late sculptor's granddaughter. "He apprenticed with his father and he modeled for him, too. Sometimes I get a lump in my throat when I drive by that park, because that's my father's face on the Pulaski monument."

Ruell gives the statue high marks for aesthetics, and Lucien made sure that it would reach even greater heights. He set it atop the largest piece of granite ever removed from Granite State Quarries in Concord—forty-two tons—and the dedication was equally grand. There were ten thousand people jammed into the park to admire his work.

He always worked to share his gifts. He developed courses in clay and plaster modeling for what was then known as the Manchester Institute of Arts and Sciences, and he taught there for twenty years, even while he continued to create works for communities throughout New England.

For all of his public work, however, too much of his work remains in private hands. Since his sudden death at age fifty-seven in 1940, too few have come into public view. That's why the bronze bust of Alfred J. Chretien—it was bequeathed to the Currier by the judge in 1975—is worth my endorsement.

So I'll go to the Currier next week and fill out my card to tell people why I like this intriguing work by this fascinating artist who chose to stay in Manchester and share his gifts with generations to come.

I hope I can find the words.

June 11, 2001

For How He Played
the Game

Boy, do my fans look out for my health and welfare. Ever since I turned forty, I've received dozens of letters urging me to retire.

Come to think of it, I've been getting those letters ever since I started writing this column. You don't think…nah, it couldn't be.

If I had a less trusting nature, I might think that people were trying to get rid of me, but I'll give those readers the benefit of the doubt and agree to retire on one condition. All I want is the kind of send-off that Mike Flanagan is going to get Thursday night from the Baltimore Orioles.

At the age of forty-two, the finest athlete ever to come out of Manchester—don't even try to argue with me on this one—is officially ending his professional baseball career. If there's a drawback to the event, it's only that the Orioles haven't figured out a way to haul every single resident of Manchester down there for the night.

For some reason—probably because they occurred with such frequency—it seems that his most mind-boggling achievements were taken for granted around here. Eighteen strikeouts in a six-inning Little League game for Temple Food Mart? Way to go, Mike. A twelve-inning, thirty-two-strikeout performance against Concord in a Sweeney Post uniform? That's our Mike.

In Baltimore, however, he is not taken for granted. In Baltimore, he's a civic treasure. In Baltimore, he is idolized, and the best part about it—what makes his parents, Edward and Lorraine Flanagan, so proud—is that his popularity is attributed more to his character than his curveball.

Consider this. A few of his contemporaries, like Nolan Ryan, Robin Yount, Dave Winfield and George Brett, will enter retirement secure in the knowledge that they will one day be enshrined in Cooperstown. Mike Flanagan will merely depart as "the embodiment of all that is good in the game."

So says Thomas Boswell of the *Washington Post*.

Yes, the finest baseball writer in America is an unabashed Mike Flanagan fan just like me, just like his parents, just like the forty-eight thousand paying customers who will gather inside Oriole Park at Camden Yards three nights hence to watch the classiest team in baseball bid farewell to one of the classiest guys who ever played the game.

And why has Baltimore embraced him so? Boswell tells it best:

> *From the time Mike arrived, the Orioles were a team that was always trying to perform beyond its capabilities. To do that, they needed a few stars to perform, like Jim Palmer, Eddie Murray or Cal Ripken Jr., but they also needed a core of players behind them who would do anything to make the difference between being a .500 team and being a contender, and Mike was the absolute symbol of that.*
>
> *Most ballplayers who are called "gamers" are everyday players, position players. Pitchers aren't seen as being tough or team-oriented. They're viewed as soloists, but with Flanagan, it was always team first.*
>
> *He pitched through ankle, knee, elbow and shoulder injuries that would have sidelined everyday players, and while fans and teammates loved him for it, it probably cost him fifty to seventy-five wins over the course of his career.*

And what a career it has been.

After starring in baseball and basketball at Memorial High School, Mike was drafted out of the University of Massachusetts by the Orioles in the seventh round in 1973. He worked his way through the minors—Miami to Asheville, North Carolina, to Rochester, New York—before reaching "the Show" in 1975.

His first big league win (over Kansas City) came on September 1, 1976. By 1978, he was named to the American League All-Star team, a season when he recorded a career-high thirteen strikeouts against the Red Sox. A year later, he was the best pitcher in baseball. He won the American League's Cy Young Award, led the Orioles to the pennant and topped all of Major League baseball with twenty-three victories.

Then came a World Series Championship in 1983 and a painful trade to the Toronto Blue Jays (for Oswaldo Peraza and Jose Mesa) in 1987. He returned to the Orioles as a free agent in 1991 (when he was part of a four-man no-hitter against Oakland), and when they close the book on him, his career record will be 167–143.

After delivering this final pitch at Baltimore's Memorial Stadium, Mike Flanagan broke tradition and waved his cap to all four corners of the field on which the Orioles would never play again. *Courtesy of Baltimore Orioles.*

"But I hope people up there will understand how much better his career was than the numbers show," said Boswell. "Some people symbolize the best in their business, and Mike was emblematic of what's best in baseball."

When asked to explain the bond he has forged with Baltimore fans, Mike's natural modesty is an obstacle, but there is no masking his genuine surprise.

"I just thought I did what was expected of me," he said. "Maybe the fans saw some of the New England work ethic showing through. I blame my parents for that, but I was always taught that if you did your job and treated people the way you wanted them to treat you, everything would work out."

If there is an event that illustrates the bond between Mike and the fans of Baltimore, it came on the final day of the 1991 season. With their new park at Camden Yards nearing completion, it was the last game that the Orioles would ever play at Memorial Stadium, their home of thirty-three years. As the game against Detroit moved into the ninth inning, the chant for Mike was deafening.

Here's how Boswell described it in the *Post*:

> *With one out in the ninth, Manager John Oates waved in Flanagan, the left-hander who is the perfect emblem of what the Orioles were for twenty-five years, have not been of late, but desperately hope they can be again.*
>
> *His black and orange jacket draped over his pitching arm, the thirty-nine-year-old war horse—assumed washed up and retired a year ago—walked to the mound bringing with him for a few minutes the very best of times.*

When he got to the mound, Mike turned back the clock. First he fooled Dave Bergman so badly on an off-speed breaking pitch that the Tigers' designated hitter laughed and flung his bat weakly toward the dugout, and then, when umpire Tim Welke refused to give him a called third strike on Travis Fryman, he got Fryman swinging on the prettiest breaking ball of his career. His job complete, he trudged toward the dugout, but the fans refused to let him go.

"The 50,700 begged for Flanagan, who hates any sort of curtain call," Boswell wrote. "This time, he not only broke tradition, he relished the moment, waving his cap to all four corners of the emerald field where the Orioles will never play again."

Now it is Mike Flanagan who will never play again.

On Thursday night, the city of Baltimore will thank him, and in Manchester we should, too. Not just for the times he won or lost, but—as Grantland Rice might say—for how he played the game.

September 27, 1993

DOUBLE DOUBLE
TROUBLE TROUBLE

It is an immutable law of physics. I even looked it up. A body in motion tends to stay in motion. So what do you get when you have two bodies in motion? Here in Manchester, you get the Gustafson sisters.

Surely you've seen them strolling along Elm Street. In fact, you probably rubbed your eyes when you saw them. You're not seeing double, though.

"But they do call us the 'Double Trouble Twins,'" said Alice Gustafson. Well, I think it was Alice. It could have been her twin, Lillian Gustafson. On second thought, I'm sure it was Alice. After all, she was born three minutes ahead of her sister, so she's used to getting in the first word.

The last word? Generally, that goes to Lillian.

It's been that way for eighty-seven years now. Precisely eighty-seven years. Today is their birthday. Or is it birthdays? (See, five or six measly little paragraphs and they have me totally befuddled already.) Anyway, Manchester's most oft-sighted siblings were born on the fifth of July back in 1912, and that initial three-minute natal separation is just about the longest the sisters—both single—have ever been apart.

And they're a big part of the early morning breakfast crowd at the Merrimack Restaurant. That's where I caught up with them last week. They had reluctantly agreed to speak with me—"We never give interviews," Alice confessed—and Merrimack co-owner Koni Farr performed the introductions.

"This is Lillian," Koni said.

"And I'm the other one," said Alice. In that instant, I knew I was helpless. A goner. They had me. Of course, it made perfect sense, because if you're talking to one, the other one is, well, the other one.

They do this to people all the time.

"Even in our own family, no one called us by our names," said, um, Alice.

If you're going to keep up with the Gustafson twins—that's Lillian on the left, Alice in the middle and Koni Farr sending them off—you'll have to march double time. *Courtesy of Tom Roy/*Union Leader.

"They just called us 'the twins,'" said Lillian. I think.

"We were the youngest of ten children," Alice said, a remark that got them rolling on names.

"Henry was the oldest," Lillian said.

"No, it was Ellen," Alice said. "Then Henry…"

"Then Ethel," Lillian said, "and Philip, Ted, Carl, Alfred…"

"…then Agnes, then us," Alice concluded. "We lived right across from the old fire station on Derryfield Hill," said Lillian. "That's where our father worked. He was the captain there…"

"…and when we were born," said Alice, "my sister Ethel went to the fire station and told him, 'Dad, you don't know it, but you have twins!' He called the chief to verify it."

Of course, it was true—hey, I was sitting right there with the proof—and from that moment on, the firefighters at the historic Hose #4 had themselves a handful. Two handfuls.

"They were wonderful to us," Lillian said. "When our mother was busy, they'd look after us."

"They had a frog pond up near the firehouse," Alice said, "and they'd flood it over for us so we could go skating in the winter."

"And then they'd take us up on the practice tower," Lillian said, "and toss us down into the nets."

"When we were six or seven," Alice said, "we got lost on Bald Hill, and the police came to find us. When they found us, they called the police station, and then they called the fire station and then they brought us home in the police car."

"I think that's when they started calling us Double Trouble," Lillian said.

The only trouble now—besides telling them apart—is keeping up with them, either in conversation or during their daily constitutionals. They gave up driving eighteen years ago, which worked out fine. Giving up the car gave them time to indulge in their favorite hobby. They like to walk the same way they like to talk.

Double time, naturally.

Alice: "We walk all the time…"

Lillian: "…oh, to Kmart, to Sears, to Clark's Farm."

Alice: "We went over to look at the flowers."

Lillian: "But we've cut down a little."

Alice: "We used to cover about fourteen miles a day…"

Lillian: "…but now we're down to eight."

Alice: "We'd wait for the bus…"

Lillian: "…but we get tired of waiting…"

Alice: "…so we walk…"

Lillian: "…and we probably get home faster."

That's a fairly typical exchange between the Gustafson girls. Following a conversation with them is like watching a tennis match. On fast forward. You have to listen with both ears, too. Otherwise you miss the jokes, poems and running commentary that mark their meals at the Merrimack.

"You just have to love them," said Koni, who knows a little bit about sister acts. She and her own sister, Maria Saitas, have been running their downtown restaurant for eighteen years now, and they know that they may have no customers more loyal than the Gustafsons. They can set their watches by them.

"They get here every morning at seven," Connie said. "They get the *Union Leader* and they swap the sections back and forth, and they have their coffee and their breakfast and they visit with everyone in the restaurant and then they're off and running."

Wherever the day takes them, as a rule. They may go home to their apartment and tinker in their flower garden or shovel the walks, depending on the season, but before long, they're on the road again—presumably to work up an appetite—so they can be back at the Merrimack by four o'clock for a late lunch.

It's a routine that would exhaust an Olympic athlete, but it's just the way they were raised. And it keeps them from raising Cain, apparently.

"What's the sense of sitting in a rocking chair?" Lillian asked. "I'd rather do something."

"Besides, it keeps us out of mischief," Alice said, with a wink.

"Our mother and grandmother were great walkers, too," Lillian added. "When we were little, they'd take us out walking every night..."

"...and in the morning," Alice said.

Lillian: "Maybe that's why I still get up at five-thirty..."

Alice: "...but I like to sleep late. I get up at five forty-five."

By this point, it was obvious that I was going to run out of ink before they ran out of energy, so we agreed to conclude the interview. Besides, it was getting on toward nine o'clock and the twins—at the age of eighty-seven—had places to go.

Lillian: "Today we might walk over to the West Side..."

Alice: "...or to the Daniel Webster Highway..."

Lillian: "...or maybe to Van Otis for chocolates..."

July 5, 1999

Byron "Monkey" Chandler

Now that the elections are over, we can only hope that the new slate of city officials won't get caught up in minor municipal issues like hospital mergers, downtown redevelopment and the civic center so they can begin to address our most pressing problem, that being the criminal shortage of competent after-dinner speakers.

As proof, consider the fact that I—a lowly newspaper geek—had to serve as emcee and keynote speaker for the recent Good Samaritan Awards.

Refunds, as I understand it, are in the mail.

Anyway, the event did give me a chance to bore the bejeebers out of more than two hundred people, although I must admit that they did seem to enjoy tales about towering titans and unsung heroes, the interesting characters from Manchester's past.

Mindful of the extreme respectability of my audience, however, I typically chickened out and failed to tell them about a really colorful character, a personal idol of mine from our city's storied past.

I'm talking about Monkey Chandler. Surely you've heard of him. No? Good. Then we have reason to carry on.

By any measure, Byron "Monkey" Chandler was not a typical role model, unless, like me, you like your role models cast in the mold of incorrigible-but-lovable womanizing bad boys such as Casanova or Don Juan.

But how, in polite circles, does one begin to describe young Lord Byron? Perhaps some genealogy is in order. He was born in 1879, the wastrel son of heiress Fannie (Martin) Chandler and George Byron Chandler, president of Amoskeag National Bank. By the time he was twenty-three, it was said that he had inherited $2 million, and in those days, $2 million wasn't chump change like it is today.

Money alone did not define Monkey Chandler, though. In fact, the only way to define him is in the language of his day—his heyday being the

If he were alive today, Manchester playboy Byron "Monkey" Chandler—shown here with second wife, Grace LaRue, and driver Alfred Jacobson—would be a staple in *People* magazine. *Courtesy of Manchester Historic Association.*

Roaring Twenties—when he would have been called a cad. A bounder. A dandy. A rake. A roué.

In short, he was a playboy. And he was short.

They didn't call him "Monkey" because he looked like Cary Grant, either. Depending on your take on evolution, the guy could have been the missing link.

However, good ol' Monkey was a debonair millionaire. If you overlook his gambling—legend says that he once dropped $250,000 at a London gaming table in a single night—he had but one weakness. It seems that he was sadly possessed of a fondness for women—specifically, young showgirls. Yes, he also had a rather insouciant approach to details like bigamy, but hey, when you light cigars with ten-dollar bills as he did, you're not one to sweat the small stuff.

For instance, on July 8, 1905, when automobiles were still a decided oddity in Manchester, the cops bagged twenty-five-year-old Byron for "running his forty-horse power Peerless car at a speed of twenty-five miles an hour in a cloud of dust on North Elm Street."

If he managed to get his car up to twenty-five miles per hour on Elm Street today, he'd get a medal.

In his car that night was his first wife, a New York stage singer named Grace Estelle Stecher. She was the love of his life, or she would have been if he lived just seven years. Maybe it was that whole seven-year-itch thing, because that's how long he'd been married when a Boston chorus girl named Joan Sawyer sued Byron for $100,000. The charge? "Alienation of affection."

The case, as they say, made all the papers. Byron was always front-page news, and not just in Manchester. Had there been a *National Enquirer* back then, he would have been their poster boy.

Now given his tempestuous state of affairs—a wife, a girlfriend and intensive press coverage—a wise man would probably have decided to lay low for a while, but Byron was not a wise man. He quickly married actress Grace LaRue.

In her day, there was no more glamorous Broadway star in the world. Grace LaRue was Bacall, Midler, Madonna and Streisand all rolled into one, which may help explain why Byron managed to overlook the fact that he wasn't technically divorced when they were wed.

Dumb? Maybe. Maybe not.

He backed his new wife in two Broadway musicals, *Betsy* and *Miss Molly May*. In the process, he won a more flattering nickname—"The Million Dollar

Kid"—and lost a fortune. Both shows went bust. Soon thereafter, Grace had depleted his holdings in London and scandalized Paris with an appearance in a "next-to-nothing gown" when she filed for divorce in 1918.

Byron claimed that she had no grounds for divorce—or alimony, more importantly—"inasmuch as the final divorce decree had not been issued to his first wife," which rendered the latter marriage invalid.

Kids, don't try this at home.

It was a nice try, but no dice. When the smoke cleared, it seemed that Byron had learned his lesson. On March 27, 1919, the *Daily Mirror* of Manchester quoted him thusly: "No man has any business to marry an actress."

He should have posted that clipping on his bathroom mirror. Within a year, he'd wed Luella Gear, another "stage actress." Some of his musicals ran longer than that marriage. Still, undaunted at the age of forty-nine, Manchester's Monkey took bride number four, Gene West. She was "a nineteen-year-old red haired dancer from Brooklyn." Can you say "sugar daddy"?

In keeping with tradition, Byron was soon divorced by his fourth wife, but even near the end, in a final interview, he was unapologetic for his life or his lifestyle.

"You could do more with a hundred dollars in a Broadway evening then than you could do with a hundred thousand dollars today," said Byron. "Back then, it was all looked on just as good clean fun, but if I tried to do the things now that I did when I was a kid, I'd be arrested in five minutes."

Funny. He was soon arrested in Miami for "sending a lewd letter through the mails." At the time, he was still a roguish sixty-two, living in a lavish mansion outside Palm Beach called the Plantation.

Within a year, he was back in Manchester—dead by his own hand—and buried alongside his parents at the Pine Grove Cemetery.

Understandably, theirs is a lavish headstone, a five-sided monument modeled after a corner of Westminster Abbey. The only thing missing is a proper epitaph for Monkey, who issued it, unknowingly, in that final interview.

"Well," he said, "I've always had a lot of swell times."

November 10, 1997

THE BURGER KING

He's not about to bite the hand that feeds him—the same hand that has fed ninety billion others in the fourteen thousand restaurants around the world that bear his name—but then again, Richard McDonald isn't the kind of guy to pull his punches either, even when you ask him how he feels about hamburgers.

"I prefer hot dogs," he says.

Wow. Tell me George Steinbrenner roots for the Red Sox. Tell me Lee Iacocca drives a Toyota. Heck, tell me Jack Daniels drinks milk. I'll believe anything now.

Given his druthers, Richard McDonald, cofounder of the burger joint that spawned the most phenomenally successful restaurant chain on this or any other planet, would prefer a hot dog—grilled, with mustard—thank you very much.

Hey, somebody fire up the hibachi! It's the least we can do for the man who is living proof that the American dream is alive and well and living here in Manchester.

Okay, okay. You got me. Dick McDonald lives in Bedford these days, but don't think for a minute that he's gone uptown on us.

This is a man whose rags-to-riches saga would make Horatio Alger blush, yet he is as modest and unassuming as the guy behind you in the checkout line at Sully's Superette. In fact, he probably *is* the guy behind you at Sully's.

He still shops there, just a couple of blocks from his parents' old house at 500 South Main Street, the one across the street from the firehouse where Captain Arnold let him ring the bell on Armistice Day, November 11, 1918, the day the Great War came to an end.

"I was eight years old, and climbing up on that truck and ringing that bell was the biggest thrill of my life," Dick said.

The trademark Golden Arches are just one of the many innovations that made Richard McDonald—co-founder of McDonald's—a legend in the fast-food industry. Union Leader *File Photo.*

Must have been some thrill, because this is a life where the list of thrills includes accepting a check for $2.7 million from an egomaniacal crank named Ray Kroc, but I'm getting ahead of myself here.

Let's begin by saying that the McDonald clan lived under modest circumstances during Dick's childhood, what with his father, Patrick McDonald, supporting a wife and five kids on his salary from the G.P. Krafts Shoe Company.

Since such modest circumstances precluded college, Dick took his diploma from West High School in 1927 and headed west, partly to dodge the economic bullet of the Great Depression but mostly to join his brother, Maurice.

"We had an uncle who was a detective in Hollywood, and he got my brother a job at Columbia Pictures, so I went, too," Dick said. "We pushed lights, we drove trucks, we even got to see stars like Clara Bow and the Barrymores. For a kid from New Hampshire, making twenty-five bucks a week, it was like heaven."

When heaven got to look like a professional dead end, the McDonald brothers took over a movie theatre in Glendora. Next they tried their hand at a hot dog stand near the Santa Anita Raceway, and then, in 1940—if this were a movie, the music would be getting louder now—they opened a drive-in restaurant in San Bernardino, a happening little town that history will remember as the home of the Hells Angels, the Seventh Day Adventists and the original McDonald's drive-in restaurant.

By 1948, the place was quite a success, but it was only a buy-a-Cadillac, live-in-a-mansion, ho-hum success. That wasn't quite enough for the McDonald brothers. Thus, Dick and his big brother—everyone knew Maurice as Mac—began to tinker with their concept.

"For instance," Dick said, "we had a huge barbecue pit with wood chips shipped in from Arkansas, but when we went back over three years of receipts, we found that 80 percent of our business was hamburgers. The more we pushed the barbecue, the more hamburgers we sold."

Their decision in restaurant lingo? They would eighty-six the barbecue. But they didn't stop there. They cleaned house. They eighty-sixed their carhops, they eighty-sixed their dishwashers and they even eighty-sixed the dishes.

For three months, the McDonald brothers shuttered their shop, and when they reopened their doors, well…they didn't have any doors. They had windows: self-service windows. The windows were the only things that needed washing, because they were now using paper bags and paper cups.

What they had done amounted to addition by subtraction.

By eliminating the carhop, the drive-in equivalent of the middleman, they had taken the food service industry and distilled it to its very essence. Now they were getting the food directly to the customer, in the shortest time possible—remember, at McDonald's, "special orders" did upset them—and at the lowest possible price, because Dick and Mac had decided to hang their hats on volume.

"Everyone else was getting thirty-five cents for a burger? Fine, we sold them for fifteen cents," Dick recalled. "Cheeseburgers were nineteen cents. Fries were a dime. So was a Coke. Our most expensive item was twenty cents. That was a shake."

And it was the shake that shook the restaurant world to its very core.

By 1954, the McDonald boys were already on the cover of *American Restaurant Magazine*—you mean you don't read it?—when a milkshake machine salesman (the aforementioned Ray Kroc) stopped by to see why one restaurant needed eight of his machines to keep up with demand.

The rest, as they say, is history. Kroc was hired on as a franchising agent, and by 1961, the brothers sold out to him for their price—$1 million apiece plus $700,000 for taxes—and retired in permanent comfort.

While his brother passed away in 1971, Dick—at age eighty-four —continues to live the life that he envisioned (alongside his high school sweetheart, the former Dorothy Jones) before he revolutionized the dining industry.

It was Dick McDonald who streamlined food production. It was Dick McDonald who pioneered self-service, and it was Dick McDonald who gave the world the Golden Arches, which first went up locally in Manchester on May 5, 1964.

Without Dick McDonald, there'd be no McNuggets, no McMuffins, no McNothing, and they know it when he stops in at the Second Street McDonald's for lunch.

Imagine the pressure? It's like singing for Frank Sinatra. Telling jokes to Bob Hope. Showing your navel to Madonna.

"Yeah, I guess it's like pitching to Babe Ruth," said owner Ron Evans.

There's just one thing that bothers me. It's this Burger King thing. Don't get me wrong. Great company, good food, clean restaurants, "hold the pickle, hold the lettuce" and all that stuff, but I have a problem with the name.

There's only one burger king.

His name is Dick McDonald. Manchester's own. The undisputed heavyweight champion of burgerdom. The Father of Fast Food. The Burger Meister. King Richard the First. The Real Burger King.

To which I can only say, long live the king.

June 14, 1993

SWEET FREEDOM

Ask any recent immigrants about the American dream, and chances are that they'll tell you it's alive and well. All too often, however, the very vividness of that dream is tied forever to nightmares that they suffered in their homeland.

Just ask Ladislau Lala. Today, his world is all sweetness and light, just like the flaky confections he sells at Lala's Hungarian Pastries, his shop on Elm Street. But there are dark memories churning below the surface, much like the cold, insistent currents of the Danube River by which six of his friends were shot and killed during a perilous flight to freedom.

His is an immigrant's story, perhaps all the more remarkable in that it is so typical of those who have found their way to Manchester in recent years.

"And it may be that Ladi's experience was less of a nightmare than many of our more recent clients," said Anne Sanderson, director of the International Institute of New Hampshire. "We've just recently resettled about fifty people from the Kosovar region into Manchester and that may have been the most dramatic exodus in the past fifty years of refugee flight from persecution."

Ladi's persecution was both social and economic. As an ethnic Hungarian trapped in Romania, he was a second-class citizen whose every move was eyed with suspicion. His father, who was banished to a communist reeducation camp in Romania for seven years after World War II, knew the same scrutiny.

"After years, he had a small pastry shop," said Ladi, whose English, while slightly broken, is still compelling. "In 1962, what the communists promised started to change—too much capitalism—and we wake up in the morning, go to the shop and it was sealed. Break the seal, go to jail. We can take nothing from the shop. Not a penny. Not a pastry. Nothing."

Ladi was ten years old, but he watched and learned.

"My father never became Romanian citizen," he said, "because the communist know if he is Romanian, he would get job, he would get pension, everything. Instead, he go to work in the black market."

Two years later, his father was dead. Ten years later, Ladi had also learned the ways of the black market. It was the only way for his woodworking business to survive.

"It was because I find a Romanian guy, a cabinetmaker, and we get very good friends. We do furniture, one a month, by hand. Then we open a shop, but the only way to get wood, get supplies, you have to open the door with your head."

He bent at the waist to illustrate his point.

"You have to knock with head because hands are full," he said. "You bring bribes. Cigarettes from the west. Coffee beans. Meat. Is like a chain. We give furniture to one guy, he gives us meat. We give meat to get wood. Is like a chain."

Then the chain tightened.

"Everybody know what we do," he said. "The chief of the police, he need a bookcase for his daughter, so we give it to him. We did very good but after eight years, we are called to city hall and mayor say, 'This is not right. You are doing too good. People get the wrong idea.' Next day, they sealed it. Done. We lost everything."

"His experience in Romania is very typical for a Hungarian," said Sanderson, whose agency helps to resettle an average of 350 immigrants each year.

"The mayor of a city like Bucharest could just decide one day that everyone would have electricity for only two hours a day," she added, "and there would be no electricity. If you had a business, if you wanted to cook, if you wanted to eat, you had to work around it. It was all controlled by city hall."

Ladi's pastry shop is just a block from city hall in Manchester now, but in 1988, such an outcome seemed a million miles away. Then came the last straw:

I was married. I have two kids. My daughter, she was in fourth grade, and she competes with students from eighth grade in the piano and she was first place for the whole country.

Now she is supposed to go to Austria, to Vienna for the competition, but a man tell me, "You can pay anything to anybody and she will not go to Vienna. She is not a Romanian." The boy who was fourth place? He went. He was Romanian.

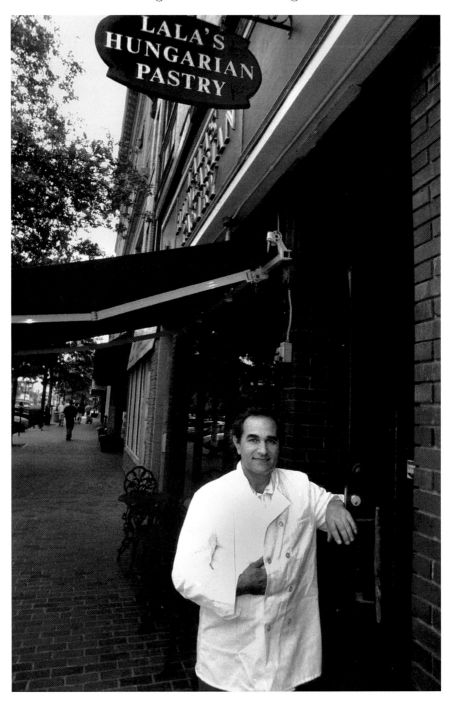

After risking his life to escape Romanian oppression, Ladislau Lala can savor the sweet freedom of running his own pastry shop in Manchester. *Courtesy of Tom Roy/*Union Leader.

It was then that Ladi knew that the only way to make a better life for his family—socially or economically—would be to flee Romania, but such a move has consequences that are difficult for an American to grasp.

"It is freedom or jail or you die," he said. "That is all, and if you go to jail, you come out half dead."

In spite of those consequences, Ladi met with his partner and one of their employees to plot their escape in June 1988. Six more men asked to join them, but Ladi and his compatriots urged them to keep their distance.

"I say we cannot go in a group," he said. "It is one, two, three men? It is one year and six months in jail. It is nine men? To be caught, it is organized against the government and it is seven years in jail."

But to stay longer in Romania would mean a lifetime of deprivation for him and his family, so Ladi and his friends arranged for a ride to the southern village of Orsova, where only the Danube River stood between them and Yugoslavia. The other six, equally desperate, mimicked their actions.

"I have some clothes and food, enough for two days," he said. "I have some money and passport I seal in plastic with the iron, and when we get to the main road at the Danube, he stop the car for maybe five seconds and we are out of the car."

Ladi and his friends found their way to a maintenance tunnel that ran beneath the railroad tracks that run along the Danube. Romanian soldiers patrol along those tracks, eyeing the river below. Meanwhile, the other six refugees headed upriver to another tunnel.

"Maybe it is from here to Merrimack Restaurant," said Ladi, meaning a distance of fifty yards at most. "We are to wait until dark. We tell the others, 'Wait half hour after we go. We leave at eleven thirty. You leave at twelve o'clock.' Everything was calm. No moon. No soldiers. No dogs. This is the mistake."

It is a fatal mistake.

At the appointed hour, Ladi and his partners pushed from the shore with a small float—"Like a toy for the pool, but Russian, so sturdy," he said of the inflatable device—to carry their belongings. It was a meager load: clothes, food and a carrier pigeon to send word to their families should they reach safety on the other side.

We are in the water maybe ten meters out and boom! [He snapped his fingers for emphasis.] *The clouds part and the moon comes out. Is no way to come back, and we look up the river and it is six heads we see. Those six guys. They are in the main stream of the river, and it is carrying them*

to us because we are not out so far. Romanian soldier don't say no warning. He open fire with AK-47. A lot of shots. Maybe three magazines. All six die, we find out later.

Silently, repeatedly, Ladi and his friends slipped beneath the surface to hide. Their tiny raft overturned, and their possessions—those that would float—drifted on the current that moved them south, away from the gunfire.

"We grab two bags and the pigeon in the case," he said. "Boat is upside down, so we put them on the bottom side and then we fight the stream."

The current in the mighty Danube was both a friend and an enemy, but the gravest danger was not in drowning. The gravest danger lay in discovery by Romanian patrol boats, whose occupants had little concern for territorial waters.

"Even on Serb side, Romanian doesn't care," Ladi said. "He pull you out."

The men were able to pull themselves out of the water miles downstream, but only after five and a half hours. After stumbling up the riverbank, they covered themselves with fallen leaves and brush to hide and stay warm. It was only after sunup that Ladi, still trembling, searched for his sealed papers.

"In one was money and documents," he said. "That is gone. In the other is a Bible page my wife say to bring. I use it to write note to Sylvia to say we are alive."

It took three hours for the pigeon, exhausted from its own ordeal, to bring word of Ladi's fate to his family. In the end, however, the note could have been longer than *War and Peace* and it would have been inadequate to describe his subsequent ordeal.

Within hours of their arrival in Yugoslavia, the three were captured by Serbian troops. Ladi feared that they would be sent back to Romania, but instead, they served twenty days in a local jail before being sent to a United Nations refugee camp in Belgrade.

After several weeks in the camp, he was sent to the Australian embassy as a candidate for political asylum. His wish to come to America didn't matter then, and come August 25—the night before he was to leave for Australia—that wish didn't matter, either. A squad of Serbian police rounded up four bus loads of Romanian refugees and headed for the border. Everyone on his bus escaped when it overturned.

For the next twelve days, Ladi and two new companions made their way south on foot. They ate roots and green oranges. They licked dew from the leaves, and they walked. They covered four hundred mountainous miles before reaching Skopje in Macedonia. Then they hopped a freight train to

Thessaloniki in Greece. It was only when he reached Athens that Ladi's luck began to turn.

While he waited for approval to come to America, he was befriended by a wealthy nightclub owner who liked his work ethic. He had a job, he had money and, thanks to his new friend, he had a forged Greek passport.

He slipped back into Romania.

"It is too long," he said. "I want to see my family."

It may have been the bravest thing he ever did, but he pulled it off. Romania had changed by then. In 1989, Nicolae Ceauşescu had been removed from office, but Ladi was not about to remain in Romania. He was coming to America. He got here November 19, 1990.

"On the first day I am here in Manchester, I put in eighteen applications for work," he smiled. "On third day, I ask for paperwork for my wife and kids to come here. I get a job at Hampshire Paper. Six bucks an hour. I don't care. It is work. Then later I am working at Stonyfield Farms. Two jobs. Leave one job, go to next job."

By the time his family arrived on April 7, 1991, he convinced them they would be sharing an apartment with three other families and sleeping four to a bed.

"But my wife, she figure it out," smiled Ladi, who by then had a fully furnished apartment waiting for them. "She heard me say about watching a movie on the video."

And you could make a movie about all that has transpired for the Lala family in the interim. Their son, also named Ladislau, graduated from Central High School and got a job with Norton Tools in Weare. Daughter Sylvia, the piano prodigy who recently graduated from Boston College, is now in medical school. Wife Sylvia now works alongside her husband, who opened his own pastry shop—much like that of his father—a year and a half ago.

I watch many times on TV there is no more American dream, but it can be realized every minute, every hour, every day. I say when God made the earth, he said, "This is the United States. Here there is everything."

Now we have everything. Now everyone is a citizen. We are Americans. This is my country.

August 24, 1999

THE MAYOR OF ALL MAYORS

It has recently occurred to me that, once they leave office, the presidents of these United States spend an inordinate amount of time raising money so they can oversee construction of lavish personal libraries that bear their names.

So presidents get libraries? Mayors get bupkis. Until now, that is.

Over on the West Side of the city, there's a remarkably complete collection that could serve as a personal library for the late Josaphat T. Benoit.

(By the way, you get bonus points if you know what the "T" stands for—I'll tell you later—and it also serves as something of a local litmus test if you pronounce his last name as Ben-OYT or BEN-wah. Personally, I am of the BEN-wah persuasion.)

Anyway, if you're new in town, you should know that Joe Benoit was the longest-serving mayor in the history of our fair city. He sat in the corner office for eighteen years, dating from 1944 to 1962—Ray Wieczorek was a distant second with ten years on the job. Given the duration of the Benoit administration, it should come as no surprise that he accumulated a lot of bureaucratic baggage.

That baggage now belongs to Gerry Hebert.

Gerry picked it up for a song this summer—boxes and boxes of stuff—and since he generously allowed me to inspect his collection over the past week, I can say with some certainty that, other than bathing in the Merrimack River, I can't imagine a more complete immersion in Queen City history.

For you younger readers, here's a Joe Benoit primer.

This Canadian-born future mayor first came to Manchester in 1937 as the editor of *L'Avenir National*, a local French-language daily newspaper, which was a nice complement to the three French-language books he had written before he got here.

He also came with three diplomas in hand, having completed undergraduate studies at the University of Montreal, where he later earned his doctorate in philosophy, after which he added another doctorate—this one in political economics and sociology—from the famed Sorbonne in Paris.

This brings to mind a remark President Kennedy made when he hosted a White House dinner for Nobel Prize winners. He said, "I think this is the most extraordinary collection of talent, of human knowledge, that has ever been gathered together at the White House, with the possible exception of when Thomas Jefferson dined alone."

It was kind of like that when Joe Benoit was in city hall by himself.

He first came to office in 1944 when, in a nonpartisan election, this New Deal Democrat beat an incumbent Republican, Wilfrid Laflamme, and from that point on, a generation of kids born in Manchester would know no other mayor.

Perhaps it was because he was a newsman himself—he even published the French-language weekly *L'Action* while he was in office—but Jumpin' Josaphat's photograph was omnipresent in the pages of the *Manchester Union* and *Leader*.

Gerry has scrapbooks full of those photos, neatly clipped from the newspaper, and my guess is that Joe Benoit cut them out of the paper all by himself.

The man had a way with scissors.

He used them to cut ceremonial ribbons all over town, as in 1947 when the "newly modernized" Post Office Fruit was reopened at Amherst and Chestnut, and he also showed up with scissors in hand later that year when Creme Freez made its debut at Maple Street and Cilley Road.

Same goes for Fijos Fur Salon—anybody remember that place?—at 1365 Elm Street, Brockleman's Grocery Store at 750 Elm Street and Jason's Jewelers at 645 Elm Street, which is not to overlook the new A&P at 1580 Elm Street. Also, since Benoit was a proud West Sider, he didn't have any trouble finding his way to the grand opening of Labreque's Radio Store at 221 Kelley Street.

Celebrities who descended on Manchester were also ushered into the mayor's office for grip-and-grin type photos, whether it be British actor Arthur Treacher (later of fish 'n' chips fame) or actress Amanda Blake (better known as *Gunsmoke*'s Miss Kitty).

He afforded the same star treatment to visitors ranging from sportscaster Curt Gowdy, *Original Amateur Hour* host Ted Mack, the Reverend Billy Graham and a former haberdasher named Harry S Truman.

The man some called J.T. was also handy with a ceremonial shovel, as he turned the first spade for the Rock Rimmon Housing Project in 1949 and

During Josaphat T. Benoit's enduring tenure as mayor, his scrapbook was filled with pictures of visiting dignitaries, including President Harry S Truman and his daughter, Margaret. *Courtesy of Gerry Hebert.*

the Smyth Road, Jewett and Gossler Park Schools in 1955. Furthermore, it was Joe Benoit who first broke ground for Memorial High School in 1959, and Gerry Hebert has the shiny shovel to prove it.

As was often the case, his name was misspelled on the shovel.

For the record—and I have his old passport and his Sorbonne student ID card for proof—his first name was spelled "Josaphat" as opposed to "Josephat," although you wouldn't know it by that incorrectly engraved shovel from Memorial or by the elegant, engraved—and erroneous—fountain pen desk set that he received in 1962 from the Manchester Independent Insurance Agents.

Given his gentle, genteel nature, Benoit would have been too gracious to make a fuss over spelling errors, and proof of his popularity was made evident after he declined to seek a tenth term as mayor. A testimonial dinner was held in his honor, and 1,400 people jammed the National Guard Armory to offer their thanks.

Gerry Hebert has the program from that dinner.

He also has all nine of his inaugural speeches and his desk calendars. He has the cap and gown and diploma from the honorary degree he received at St. Anselm College. He has the flags that provided the backdrop for each and every photo of Joe Benoit that was taken in his city hall office, and he even has the obituary that marked the man's passing on May 10, 1976.

As for that middle initial? The "T" in Josaphat T. Benoit? It stands for Theophile.

And I'm happy to say that his files are in good hands.

October 31, 2005

THE JOY OF MUSIC

In its purest form—before Hollywood got a hold of it—country music was a plaintive kind of music, filled with sorrow, hardship, pain and loss.

That's the kind of country music that Clyde Joy has sung for fifty years.

It's got that first verse, full of joy and sunshine. Then there's the second verse, with the heartache and the pain, and then, if you're lucky, there's a chorus that kind of picks you up and carries you through to the end.

Back when Clyde got started, that stuff wasn't called country music. It was cowboy music, hillbilly music, and even though half a century has gone by, it's the kind of music that he still sings. In fact, it's the kind of music that he played a little while ago during a rare engagement at the Ukrainian Club in Manchester, the city he still calls home.

For Clyde, the first verse started when he was a student at Central High School back in the 1930s. That's when he bought his first guitar for half a buck, and so what if he had to use pliers to tune the thing. It was good enough to get him through his first talent show at Central, where Rodney Wiggin convinced him to warble his way through "When It's Lamp Lighting Time in the Valley."

Okay, so he didn't win anything. He did get an infectious dose of audience response that launched his musical career, and soon enough he recovered his initial investment when he won first prize in a talent contest—two dollars.

"All I needed was to get up there and get a hand and I was hooked," said Clyde, who is pushing seventy-five as smoothly as he pushes cassette tapes at his performances.

"Back then, the cowboy or hillbilly songs all had yodelin' in 'em, and once I heard yodelin' by a guy named Montana Slim, I knew I'd found my life's ambition," he said.

He began to realize that ambition in a humble sort of way, with a booking at Arthur's Fried Clams out on South Willow Street, where the cars would

Although he would come to know sorrow, there was no stopping Clyde Joy, whose country music programs truly brought *Joy in the Morning* to his audience in Manchester. Union Leader *File Photo*.

park out behind the clam shack and listen to the skinny kid with the cowboy hat and fifty-cent guitar.

He got two bucks a night for that engagement, and by 1936, he hit the big time—crooning for the roller skaters at Pine Island Park and the Bedford Grove for five bucks a night, an unheard-of sum at the height of the Depression.

If Clyde's taste in music was ahead of the locals, so was his media sense. If he could play in front of a couple hundred people at the Bedford Grove, how many more could he reach on the radio?

With sponsorship from the Liberal Credit Clothing Store, he found out. Clyde got a fifteen-minute daily show on WFEA radio.

"I used to get paid fifteen dollars for that fifteen-minute show, a damn sight better than working at the chicken farm on Webster Street," he said. "I used to brag I was getting a buck a minute. I was rich when I got paid."

Before long, he was everywhere on live radio, hauling himself all over the state in a Model-A Ford to sing a couple of songs, make a little dough and plug a couple of dance dates, whether he was playing along with Baron and his Texans or with Buck Nation and the Cowboy Caravan.

Even when Uncle Sam stepped in and slowed his rising star, Clyde turned a hitch in the service to his advantage. While stationed down south, he married Willie Mae Gibbons, and in the relatively short span of ten years, thanks to the magic of television, the duo of Clyde and Willie Mae Joy were household names in New Hampshire.

First there was *The Country Store Show* with Gus Bernier on WMUR-TV, then it was the *Coffee Time Show* and then it was top billing—*Joy in the Morning*, with Clyde and Willie Mae and the Country Folks.

For fifteen years, Clyde Joy was living his dream. He was earning his keep singing his songs, sharing the stage with the likes of Johnny Cash, George Jones, Hank Williams Jr. and Tex Ritter, and he was doing it in his own backyard, at places like the Lone Star Ranch in Merrimack, which meant everything to him.

"People always told me if I could eke out half a livin' up here, I'd do great anywhere else, but I just hated the South," he said. "I love to hunt and fish, and I just loved New Hampshire, so I wasn't leavin'."

In 1966, at the height of his fame, he opened the Circle 9 Ranch in Epsom. In hindsight, that was as high as his star would rise. That's when the first verse—the one about sunshine and roses—came to an end.

Then it came time to sing the second verse.

In 1967, a twister roared through the Circle 9 and left splinters in its wake. Two years later, his youngest son, Billy, was killed on his final

patrol in Vietnam. By 1973, Willie Mae was gone—run off with his guitar player—and the next year, he lost the Circle 9 to the bank. Clyde Joy, the man who brought music to millions, found his only solace in the bottle.

"I guess it was all bad," he said, "but when Billy got killed, it just knocked the hell out of me. I was on the booze pretty bad and so was Willie Mae, and then when she left, I tried to make it a joke. I told people I really missed that guitar player."

"I guess I was flat on my ass for a long time before I finally made up my mind to straighten up my life and live up to what my son died for," Clyde said, and for him, that meant making music again.

If the fall was swift, the climb back has been agonizing, but in the past three years, he has been inducted into the New Hampshire Country Music Hall of Fame and received the Country Music Association's American Eagle Award for lifetime achievement.

He still slips away from time to time to get in a little hunting and fishing, and with the help of the former Mazie Hamilton of Manchester, he stays away from the booze. Even though the crowds are smaller nowadays, he still picks his spots and plays his songs.

After fifty years in the business, Clyde Joy has finally made it through the second verse. He's settlin' nicely into the chorus of life.

April 1, 1991

PEYTON PLACE

Tell me if this sounds familiar. A bright young writer from Manchester—a free spirit with working-class roots who likes to wear jeans and sneakers and also enjoys an occasional touch of the grape—writes a shockingly successful first book that tickles some and offends others en route to making the author a household name.

Me? Hardly. I'm not even a household name in my own household.

No, I'm talking about Grace (de Repentigny) Metalious, the Manchester native whose first novel was like a fingernail on the chalkboard of America's social consciousness more than forty years ago.

Perhaps you've heard of it. It was called *Peyton Place*.

Critics called it "crude," "immoral," "vulgar" and "senseless," but remember—God's honest truth—those are precisely the words that Leo Tolstoy used to describe the work of William Shakespeare.

Besides, that kind of critical language may make authors cringe, but it makes publicists salivate, and thanks to the clever exploitation of that puritanical outcry, Grace's hard-bitten, soft-core assault on small-minded, small-town America became the most successful first novel in publishing history.

Within ten days of its publication in 1955, more than sixty thousand hardcover copies of *Peyton Place* had been sold. Since then, more than ten million copies have been put into print, including editions in French, German and Spanish, not to mention Italian, Japanese, Danish, Norwegian, Swedish and, yes, even Hebrew. (That Allison MacKenzie, what a mensch!)

Not bad for a kid right out of Janesville, a graduate of the Ash Street School who went on to flunk English as a sophomore at Central High School.

Understandably, a lot of folks around here are unaware of Grace's ties to Manchester. It's not like there's a school or a park named in her honor.

Nonetheless, her writing roots were firmly planted in the soil of this city, even if it has yielded rather a bitter harvest.

"I don't know that we'll ever see a Grace Metalious Park in Manchester," said historian Robert Perreault, who conducts occasional seminars on *Peyton Place* for the Manchester Historic Association. "This city has enough trouble honoring its own history, so I wouldn't hold my breath waiting for it to honor an author who provokes thought, even when it's one of our own."

Bob's interest in Grace Metalious is a matter of scholarly record. In addition to his published works regarding her French Canadian ancestry—her given name was Grace Marie-Antoinette Jeanne d' Arc de Repentigny—and its influence on her writing, he also conducts walking tours past the various homes and apartments where she lived here in Manchester.

"For me, she's like a hometown hero," he said. "I know a lot of people don't see it that way, but I think she deserves a second chance…She and her book just got caught up in the sensationalism of the day, but now that the dust has settled, I say let's go back and read the book. It's a fine piece of writing."

Unfortunately, a series of events—including one flip remark by the author—hoisted it beyond the realm of literature and into the category of social phenomenon.

Just as *Peyton Place* was about to be released, Grace's publisher hired a hustling publicist whose previous clients included literary giants like Captain Kangaroo. When he brought Associated Press columnist Hal Boyle to visit Grace's home in Gilmanton, New Hampshire, she joked that her husband—fellow Manchester native George Metalious—would probably lose his job as principal of the local high school because of the book.

Sure enough, by the time Boyle's column ran, that offhand remark was written as fact. In fact, it became a self-fulfilling prophecy, and even without scandal sheets like the *National Enquirer* or tabloid TV shows like *Hard Copy*, the racy *Peyton Place* caught fire.

It didn't hurt that Grace was occasionally, um, ungracious.

"To tourists, these towns look as peaceful as a postcard," she told Boyle. "But if you go beneath that picture, it's like turning over a rock with your foot. All kinds of strange things crawl out."

She bristled when asked if the book was autobiographical. One interviewer had the audacity to pose the question on live television—ever hear of Mike Wallace?—so she retaliated by calling him Myron—he really hates his given name—and asking him how many times he had been married.

Under the withering glare of the spotlight, Grace hit the bottle harder than ever. Her subsequent work suffered accordingly, but still, within the next

They called her "Pandora in Blue Jeans," but Grace Metalious didn't open a box. She claimed she turned over a rock, and America didn't like what she found in *Peyton Place*. Union Leader *File Photo*.

ten years, she cranked out a sequel to *Peyton Place* and two other novels—*The Tight White Collar* and *No Adam in Eden*—the last of which holds particular ties to Manchester.

"It's probably the least known of her four books, and it is depressing," explained Bob Perreault, "but there's so much local color in it that I thought it was delightful. If you know Manchester, you can read that book and identify everything she's talking about."

The folks from the New Hampshire Humanities Council are talking about Grace. As part of a program entitled What New Hampshire Is Reading, the council is sponsoring a series of discussions around the state on *Peyton Place*.

So why would Granite Staters read a forty-year-old novel? That's what I asked program coordinator Debbie Watrous.

"For one thing, it fits well in the context of our whole project, which is to study New Hampshire voices, different ways of looking at who we are in this state," she said.

> *It started last month with* Our Town *by Thornton Wilder, which was a very nice view of small-town life. I think it's safe to say that Grace Metalious had a totally opposite view.*
>
> *I'm not going to say it's great literature, but it is a good book, and a lot of people don't know that because of the firestorm when it was published. I think it's interesting to see what she was saying about the human condition from her point of view, what she was saying about men and women, about the wealthy and the underclass and rape and incest and alcoholism and things people didn't talk about in the 1950s.*

Except for Grace, that is.

She talked about it, she wrote about it and she paid a price. She died a tragically premature death in 1964 at the age of thirty-nine due to alcohol-related ailments, having squandered—for the most part—her fortune and her talent.

But now she is being resurrected in the city of her birth. So take a chance. Read the book. (Adults only, please.) Have your friends read it, too. Then get together with those friends and start a discussion and recognize the achievements of this remarkable woman.

Just do me one favor.

Try to ignore the part about the gossipy neighborhood know-it-all named Clayton.

October 31, 1994

A Show of Respect

The sun had yet to breach the eastern horizon yesterday morning, and yet, these men and women—these guardians of our society—were streaming in to Manchester.

They came from near and far. They came from Hooksett and Candia, from Deering and Meredith, from Hampstead and Nashua and Portsmouth. They came from Boston and Woburn and Cambridge. They came from Chester, Vermont, and Providence, Rhode Island; from Tampa, Florida, and Reno, Nevada.

They came because they are honor-bound.

There were police chiefs, captains, lieutenants and sergeants, but on this day, the only soul with privilege of rank was Michael Briggs, a patrolman, whose ultimate sacrifice set into motion the sad and magnificent procession that was taking shape in the early morning hours on Elm Street.

Without exception, the words of those who gathered were brief. It was their presence that spoke volumes.

"It's out of respect," said Bill Foster, a motorcycle cop from Ashland, Massachusetts. "He gave it all."

"We're here to show support for the Manchester Police Department and our respect for him and his family," said Lieutenant Rich Ardi of the Carroll County Sheriff's Department.

"It could be any one of us, you know," said Detective Lieutenant Richard Laurier of the Massachusetts State Police. "The guy was out there working. It could have been any one of us."

As the sky began to brighten, the numbers increased.

Motorcycle officers rumbled slowly toward Elm and Salmon Streets, as some two hundred took their places at the head of the procession. Mounted patrol units began to queue up in a semicircular driveway. They were aligned two-by-two but for the sole, riderless horse at the lead.

It is a heart-rending sight, this riderless horse.

It represents the warrior who will never ride again, empty boots reversed in the stirrups. It would fall to Sergeant Kevin Kincaid of the Manchester Police Department to take the reins and lead King Arthur—a massive, ebony Percheron draft horse—through the procession.

"It's a great honor," he said, as he gently stroked King Arthur's muzzle. He continued to speak, his voice soft, speaking as much to the horse as to me. "As police officers, we have to be in control. We don't get to express a lot of emotion," he said. "This is our grieving process."

As we spoke, a sea of uniformed men and women began massing and assembling on Elm Street. It was an hour before the procession was to step off, yet smaller groups merged with larger groups and orderly rows began to form.

In some areas, they stood sixteen abreast.

There were cops, firefighters, corrections officers, sheriffs and deputies, conservation officers and ambulance drivers. There were officers in plainclothes—wild beards and haircuts temporarily betrayed those working undercover—plus honor guards, elected officials and assorted dignitaries, but no one stood with more honor and dignity than the men and women of the Manchester Police Department.

There are strict rules of protocol in a quasimilitary organization, but on this day, Manchester's finest were allowed one minor, acceptable breach of uniform standards. Each wore a small, circular, gold-trimmed silver medallion. On its face was the number "83."

That's the badge number of Michael Briggs.

The sun climbed higher into the sky. It glinted off those medallions as, inside the funeral home, members of the Briggs family shared their last private moments with Michael. As they said their goodbyes, his vast extended family—four thousand men and women in uniform, by some accounts—stood silent and motionless on the street.

At 8:55 a.m., the door to the funeral home was slowly opened. Inside the door, there was a glimpse of the American flag.

A state trooper barked: "Detail, ten-hut!" A blizzard of white gloves snapped to salute.

It was like a moment frozen in time, and it's forever frozen in my memory, as the flag-draped casket bearing the remains of Michael Briggs was moved—slowly, reverently—to the waiting hearse. There was a low rumble of idling motorcycles, the snap of flags in the wind.

Otherwise, utter silence. It seemed an eternity. It ended when the trooper barked out again.

Towering Titans and Unsung Heroes

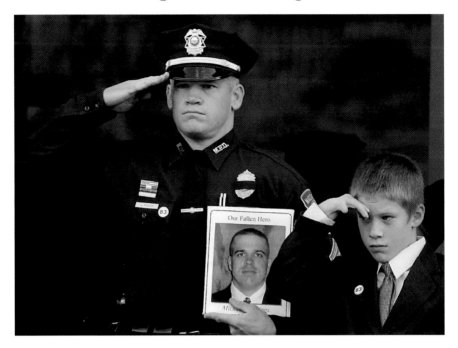

The show of respect for Officer Michael Briggs was sad and magnificent but nowhere more touching than in the quiet tribute offered by Officer Jim Soucy and his son, Isaiah. *Courtesy of Mark Bolton/*Union Leader.

"Detail! Right face!" was the command, and when the procession snapped off a quarter-turn to face south, the well of emotion was so deep, so moving, that I—and many of those around me—wanted to believe that we were bearing witness to a once-in-a-lifetime display of honor and respect.

If only it were so.

A police funeral is a majestic demonstration of sorrow and gratitude, but for all of its majesty, it is diminished by frequency. It is rich with tradition and steeped in history, and for the sake of the men and women who protect us, we need to convene far less often for this sad purpose.

These are the guardians of our society.

So yesterday, as the nine o'clock hour arrived, they set forth—in a sad and magnificent fashion—to honor Michael Briggs in the town where he was born and the town where he died.

Their ranks were diminished by one. But make no mistake. Their resolve was made stronger by his sacrifice.

October 22, 2006

THE FATHER OF
VIDEO GAMES

Pretend you're in Nashua. Pretend it's 1966. Now pretend you're tucked away in a tiny, windowless room on the sixth floor of the Sanders Associates plant on Canal Street. Now pretend you've come up with a notion that will spawn a multibillion-dollar industry and revolutionize leisure habits the world over.

Ralph Baer doesn't have to pretend. He was there. That's when he invented the video game.

When the first primitive prototype was finally up and running—it was May 7, 1967—Ralph challenged a colleague, Bill Harrison, to a mano-a-mano video ping-pong contest that, in the great, grand scheme of global events, would prove to be far more momentous than any ten Super Bowl/World Series/Stanley Cup/NCAA Final/steel cage death match–type encounters you can name.

The outcome?

"I lost," Ralph shrugged.

And kids today would be lost without him.

So would arcade owners, retailers, manufacturers and everyone else —hand-wringing psychologists and sociologists included—whose fortunes are somehow tied to the video game industry that topped the $7 billion mark last year.

Of course, making such a claim triggers hairsplitting of the highest order—*Pong* was a nice little saloon diversion but Nolan Bushnell of Atari did not invent the video game. So don't examine your Nintendo 64 or PlayStation and look for Ralph's name. And don't call me if you can't find his picture in the instruction manual that came with your Sega Dreamcast.

Ralph didn't invent every game.

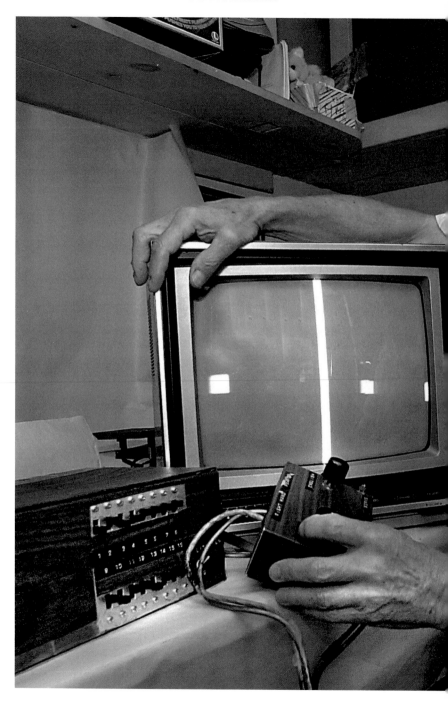

Inventor Ralph Baer calls it "the Brown Box," but to the U.S. Patent Office, patent #3659285 was issued for the very first "Television Gaming Apparatus and Method." *Courtesy of Bob LaPree/*Union Leader.

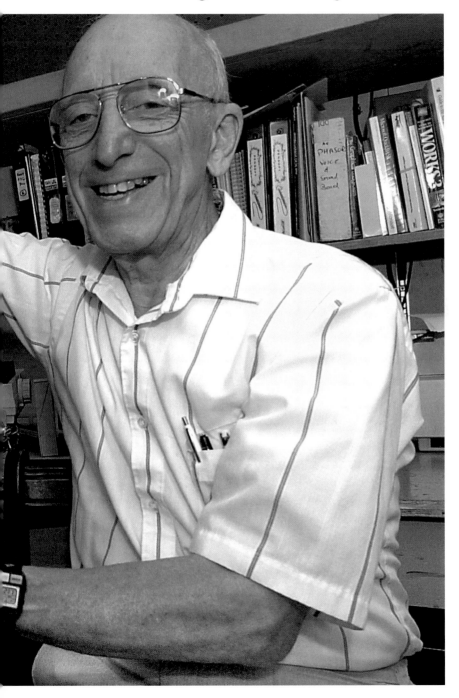

He did invent the concept from which every game has sprung—*Electronic Gaming Monthly* magazine finally caught up with that fact in its January issue—and he's grown accustomed to making the distinction.

"When somebody introduces me as the guy who invented video games," he explained, "the next question usually is, 'Which game did you invent?' It doesn't seem to occur to people that before you can invent games, maybe somebody has to think about playing games on a screen; in particular, the screen on a television set at home."

Since I don't want to bore those of you who are video game players—we all know you have the attention span of gypsy moths—I'll skip over Ralph's incredibly compelling personal history involving his escape from Nazi Germany at age fourteen and tell you that he first began tinkering with the notion of a video game in the 1950s when he was hired by Loral—a major military electronics contractor—to build a TV set.

"All along, I kept suggesting to management that they do something novel with the TV set, like play games. And of course, I got the regular reaction. 'Who needs this?' And nothing happened."

Things happened at Sanders, though.

"It was a big company, but I could do what I wanted," said Ralph, who joined Sanders in 1965 and served as chief engineer for equipment design. "They let me work with a small group, sometimes two or three people doing research and design, but I lived two lives. I was on both sides of the fence, doing military design and the game."

That game—dubbed "the Brown Box"—should be in the Smithsonian, but it's in the basement workshop in the North Manchester home that Ralph shares with his wife Dena. He's not trying to keep it under wraps—heck, Sanders did that for five years with a "top secret military classification"—but he does try to keep it working.

At thirty-four, it's still working. At seventy-eight, so is he.

Not that you'd know it around here. Ralph has enjoyed relative anonymity in Manchester, but the rest of America is frequently agog at his achievements. Consider the sensational newspaper accounts his work has generated down through the years.

"Ralph Baer Changed Course of Civilization," blared a headline in the *Ashland* (Kentucky) *Independent*. "Inventor Alters Lives," claimed the *Juneau* (Alaska) *Empire*. The *Conway* (Arkansas) *Log Cabin Democrat* billed his success as "One Man's Gift to Mankind," while the *Cherokee* (Iowa) *Times* introduced him to readers as "The Thomas Edison of TV Games."

That's heady stuff, but Ralph hasn't let it go to his head.

"Inventing is easy," he said. "Building hardware is easy. Creating software is easy. Selling is hard. It's a hell of a lot easier to create the product than to create the demand. That's why marketers drive Cadillacs and engineers drive Chevys."

He drives an Avalon, if you're going to get technical, and if you're going to get technical, you probably need to know that the U.S. patent for "A Television Gaming Apparatus and Method"—#3659285—was issued to him on April 25, 1972.

Are there pretenders to his throne? Absolutely.

Seems like every cowboy and keypuncher with a computer has tried to lay claim to the video game at one time or another. In fact, under the Sanders banner, Ralph spent years traveling around the country testifying in untold patent infringement suits that put untold millions of dollars—$16 million from Mattel alone—into the company's coffers.

His take? He's not telling. What is telling, however, is that when the Classic Gaming Expo 2000 was gaveled to order in Las Vegas last month, the keynote speaker and guest of honor was Ralph Baer.

"It's an ego trip," he smiled. "All this adulation, people coming up to you for autographs. It's not very often that engineers get asked for autographs, and what made it nice was this was the first time, this time in Vegas, when nobody asked me how much money I made."

It's not about the money with Ralph. It's about the games, games he had a direct hand in; games like *Odyssey* by Magnavox, Coleco's *Telstar* and *Simon* by Milton Bradley.

But, lest you think a chat with Ralph is all fun and games, think again. It was like a crash course in electrical engineering, what with talk of radiation specs, binary codes, optical interfaces, vestigial data, second harmonics and radio frequency interference-type information that made my head spin.

Ralph could see it happening.

People ask what I do and I tell them, and in thirty seconds, their eyes glaze over. That's the problem with my book. I want to write my memoirs, but it's too technical, and if it's too technical, what does that mean to most people? Zip. A better writer could make something of it, but coming out of me? I'm afraid it would be boring to all but a handful of people.

In closing, more than a handful of people will be pleased to discover that this man, this genius, this inventor who has fifty patents in the United States and another one hundred worldwide, is—like the rest of us mortals—wrestling with new technology.

"It's ridiculous," he said. "I bought a new VCR, and it took me four or five hours to program it. It has a ninety-page instruction manual. I bought a new cellphone and it has a one-hundred-page manual. It's insanity, I tell you."

August 19, 2000

ADAM SANDLER'S GIFT

Snooty, hoity-toity movie critics may blanch at the notion, but I can give you a million reasons to love Adam Sandler.

He's giving $1 million to the Manchester Boys & Girls Club.

Word of the actor and comedian's stunning gift became known when officials from the Boys & Girls Club asked me to break the story on the day they kicked off a $6.6 million capital and endowment fundraising campaign called "Building Better Lives."

"This is my first capital campaign and Adam was my first solicitation ever," said Steve McMahon, the chairman of the Boys & Girls Club board of directors. "When we were just getting started, I would lie awake in bed at night and say, 'Where do we start raising $6.6 million? And whose name would provide the most pizzazz?'"

The answer was Adam Sandler.

As a fellow Boys Club alumnus, I was happy to deliver the news of Adam's gift, but I have a nagging confession to make. I've been to three Adam Sandler movies in my life, and in each case, I was paid to attend.

Thus far, I wouldn't have it any other way.

Nothing against Adam, mind you. He's a Manchester guy, I'm a Manchester guy and we have a lot of mutual friends, and these mutual friends are always telling me how hilarious he is, which just proves...well, which proves nothing.

When it comes to Adam Sandler movies, I just don't get it.

I want to get it. I really do. No one is a bigger fan of "local boy makes good" stories than I am, and commercially speaking, Adam Sandler is, without question, the single most successful entertainer ever to come out of New Hampshire.

His numbers are staggering.

After winning his spurs on NBC's *Saturday Night Live*, he got supporting roles in films like *Airheads* and *Mixed Nuts*. Then he landed a starring role in *Billy Madison*, portraying a sensitive but angry illiterate heir to a family fortune who falls in love with his remedial grade school teacher. The critics savaged it. It grossed $25.5 million.

Then he starred in *Happy Gilmore* as a sensitive but angry hockey player trying to make it on the pro golf tour in order to rescue his grandmother's house from IRS foreclosure. The critics ravaged it. It grossed $40 million at the box office and $35 million more on video.

Then came his next film entitled *The Wedding Singer*, which I was asked to attend for professional journalistic reasons. For ninety-six minutes, I was awash in a film that was short on laughs but long on songs, really bad songs from the '80s—Culture Club, Thompson Twins, Madonna—a techno decade of music that almost made me pine for the depth and complexity of disco.

Now I'm not a full-time movie critic, but I did play one on WNDS-TV, and as I wrote back then, if I had to describe my feelings about *The Wedding Singer* in a single word, the word would have been "mixed." I was not alone.

Roger Ebert said that the film was further evidence of the "dumbing down" of America, while *Mademoiselle* magazine's Anne Marie O'Connor —who is on either drugs or the payroll of New Line Cinema—said it was a "screamingly funny 80s flashback."

Of course, the truth probably lies somewhere in the middle, and what matters most is that Adam Sandler—with his amazing gift to the Boy & Girls Club—has put himself smack in the middle of one of the most important fundraisers for one of the most important institutions in the city.

Among his many suitors was Stanley Spirou.

Stan now serves as men's basketball coach at Southern New Hampshire University, but in 1984, he was a sociology teacher at Manchester High School Central, where he found himself competing for laughs with a curly-haired senior.

"*Saturday Night Live* gets all the credit, but I taught Adam how to be funny. He kept stealing my thunder in class, and here he is doing it again," Stan laughed. "I was happy to help the Boy's Club, but this isn't about me. This is all about Adam having a big heart. A lot of times when people make it big, they forget where they came from. Not Adam. He hasn't forgotten his roots."

The fact that the Boys & Girls Club was a part of Adam Sandler's Manchester upbringing became clear in a remarkably informal video greeting that was shown at the press conference announcing his gift.

Whether he's giving the graduation speech at Central High or donating $1 million to the Boys & Girls Club, Adam Sandler remembers his Manchester roots. *Courtesy of David Lane/ Union Leader.*

To prepare the greeting, the Golden Globe nominee (for *Punch-Drunk Love*) had to take time out from a film project. He was playing an Israeli Mossad agent turned hairdresser—his co-star was singer Mariah Carey—in a film titled *You Don't Mess With the Zohan*, but he was in a non-Hollywood, nonglamorous, living room setting when he addressed the camera for the Boys & Girls Club.

"Hello, everybody out there in Manchester, New Hampshire–land," he said. "Did you hear they need to expand the Boys & Girls Club? They need money. I gave some of my money. I felt good about it because I have a lot of good memories of that place."

Decorum requires that we depart from the video at that moment, as Adam slipped in a bit of his trademark, potty-mouthed humor—humor that drew a roar of approval from the kids and a knowing cringe from most of the adults.

"It's Adam being Adam," shrugged Steve McMahon. And so it goes...

I keep telling myself that maybe Adam is in the midst of a Jerry Lewis thing. While I keep waiting for him to deliver a cohesive, breakthrough, tour-de-force performance that might put him in the comedic realm of, say, Steve Martin or even Denis Leary, maybe one day the people of France will present him with the Legion of Honor and I'll realize what a dope I was to have overlooked this genius in our midst.

In the meantime, I'm sure Adam—a most giving and generous guy who's returned to his alma mater twice to deliver commencement addresses—is laughing all the way to the bank.

And I couldn't be happier for him if I was, well...if I was Happy Gilmore.

October 24, 2007

THE FABULOUS
FAY MCKAY

A quick quiz: can you name the one-time class clown at Manchester High School Central who went on to forge an amazingly successful career in show business essentially by performing the same antics that drew howls in high school?

Adam Sandler, you say? Good guess.

It would be a correct one, too, but for one thing. Long before Adam Sandler, it was Fay Gelinas—CHS '48—who reigned as Manchester's leading comedic export. These days, she's better known as "the Fabulous Fay McKay," and she's alive and well and living in Las Vegas.

That's where she's enjoyed her greatest fame, but she's been a household name around the Queen City since she started cutting up for her classmates.

"I used to sing and play the piano—just enough to accompany myself—and I used to make the other kids laugh by doing impressions of the teachers at Central," she said. "Mr. [William] McAllaster saw me and I must have been starting to show some talent because he had me do the entertaining at assemblies and pep rallies."

It's funny to hear her say she was in her prime at that time—funny because of the heights she was yet to hit.

"I didn't want to leave high school," she said. "It was the most wonderful time of my life. I graduated in 1948, but I went back the next two years and took postgraduate courses. I wasn't really a good student, but they liked having me around."

They liked having her around at the R.G. Sullivan Cigar Factory, too—maybe it had something to do with her Jimmy Durante impression—and it was the same when she worked as a waitress at the Puritan Restaurant and as a chambermaid at the Elms.

Liberace called her "the greatest bunch of fun in show business," but early on, her friends in Manchester knew that Fay McKay would have a career that was simply fabulous. Union Leader *File Photo*.

"I sang there on weekends, too," she said. "They had a lady who lived there six months of the year, and she knew all the old tunes, so they let me get up there and sing with her. I didn't get paid for it, but that was okay. I loved to sing."

Eventually, she sang for a talent scout. Next thing she knew, she was in New York.

She appeared on the radio version of *The Original Amateur Hour* hosted by Ted Mack, and her act carried the day. Actually, it carried three days, because she won three shows in a row in 1950 and was invited to join nine other three-time winners at Madison Square Garden to determine the national champion.

Naturally, this was big news back home. A front-page story in both the *Manchester Union* and *Leader* recounted her performance at that Garden party, and Elden Murray—he was executive secretary of the local chamber of commerce—beseeched radio listeners to mail in their votes for Fay.

They were anyway.

"Oh, we sent postcards," said Cellie Bolduc, a childhood friend of Fay's who lived around the corner from the Gelinas home at Pearl and Union. "My sister-in-law remembers her family sent in as many as five hundred postcards for Fay."

It paid off. It took two weeks to tally all the votes. When they announced the results, Fay was declared the winner, but it would be weeks before she would find out. Always on the lookout for talent, Ted Mack knew what he had in Fay, and she'd already been spirited away to join his troupe on a European tour.

She came home, eventually, and when she did, she was on a mission. It was a mission of mercy because a fire had destroyed her home parish —St. George's Catholic Church—and she enlisted Ted Mack to come back with her.

He brought his entire entourage—even Tony "the Garage Man" Russo—but the unquestioned star of the show was Fay Gelinas.

The bundle of energy billed as "the Songbird of Manchester" wowed the crowd with three numbers. They packed the National Guard Armory for that show on April 15, 1953, and the money raised—even while raising the profile of local amateur performers like Clyde Joy and Bucky Searles—helped her neighborhood parish arise from the ashes.

So what, exactly, was her act?

"I was at the piano, and I was doing impressions of all the artists that were well known in those days," Fay said. "I did Kate Smith and Ethel Merman. I did the Ink Spots—not all four of them, though—and people like Rose Murphy, Jerry Colona, Teresa Brewer and Kay Starr."

She forgot to mention Jimmy Durante, so I will.

In spite of my tender years, I even got to hear her take on the Great Schnozzola, because—thanks to the extensive vintage record collection of D.J. Bobby Dee and the technological wizardry of Richard Gesner at the Music Connection—I've spent the past week listening to Fay on the CD player in my car.

The recording in question is her 1968 LP called *Fay McKay: A-Live At The Dunes*, and it captures the improvisational brilliance of the woman whom Liberace once called "the greatest bunch of fun in show business."

> *But you know, we recorded the show in Denver. I had been doing some voice-over work for commercials, and the man in the recording studio—Fred Arthur—he said, "If you ever do a record, I want to be there." Everyone loved the show, so we recorded it in a nightclub in Denver, and when I went back to Vegas, we sold it after the shows.*

Over the years, even while she was becoming a part of the Las Vegas landscape at the Landmark, the Dunes, the Aladdin and the Stardust, Fay —who adopted McKay as a stage name—toured and traveled. She played everywhere, from the Palladium in London to the Dorothy Chandler Pavilion in Hollywood. She was also a staple on afternoon talk and variety shows alongside hosts like Merv Griffin and Mike Douglas (and if you're interested, there's a VHS recording of her 1970 appearance with Mike Douglas—along with Liberace and Little Richard—that's available on Yahoo.com).

These days, however, the pace is slower. At seventy-two, she likes it that way.

"It's not my era," she said. "At the end of my days here, I could see it fading out. You could see the writing on the wall, and a lot of the people who performed in that era knew it was time to move on."

When that time came for Fay, she moved on to the Sunrise Ranch in Loveland, Colorado. It had always been something of a spiritual retreat for her—you need one of those when you work in Las Vegas—and it was where she went to reflect and recharge. Still, four years ago, she went charging back to Las Vegas.

"Part of it's for the weather," she laughed, and she still has a great laugh. "I have arthritis now. That, and I'm old. I'm still going to sing though, but I'll only sing in the restaurant lounges. In fact, I'm trying to gather up some money now so I can have my own place."

"I'll call it Fay's Place," she added, "and I'll let all the old-timers come. We'll get all those folks out of the nursing home, and we'll put on one heck of a show."

October 7, 2002

FERRETTI'S MARKET

I was too big for the shopping cart and too little to leave in the car, so come Friday night—Friday was payday back then—I'd grudgingly trail behind my parents as they breezed through the aisles in J. Ferretti's Market at Bridge and Elm, back when Bridge and Elm was the Times Square of Manchester.

I trailed them grudgingly because I knew if I managed to look forlorn enough, a nice man would give me an apple. The man was Arthur Ferretti.

He died on Wednesday at the age of ninety-six.

To people of a certain age, his passing brings an end to a remarkable chapter in Manchester's history, one in which the immigrant experience—in this case, the Italian experience—was carried to Horatio Alger extremes.

It started in 1885 when Joe and Rosa (Bruno) Ferretti, just two years off the boat from the Italian village of Carpeneto, opened a small tobacco store at the corner of Elm and West Central. All it took was their life's savings—all thirty-five dollars—but they made it their life's work.

It's a life they passed on to their four children, Mary, Victor, James and the baby—that was Arthur—and in so many ways, they touched our lives.

The kids took over from Pappa Joe in 1917, when $200 was an outstanding weekly gross. They moved north toward Lowell Street in 1926, and come 1933, the Ferretti name was so big that the four siblings opened that grand, brand-new store at Bridge and Elm, and grocery shopping in Manchester would never be the same.

There were other grocery stores, to be sure. There were chains like First National and A&P, and Manchester also had its share of quality independent grocers to compete with Ferretti's—like Maurice Katz at the Federal Market, John Sullivan at Sully's and Romeo Champagne, who owned Champagne's (before it was bought by Grand Union)—but as grand as those stores were, in its heyday, the granddaddy of them all was Ferretti's.

Even in the hardscrabble 1930s, the produce counter at Ferretti's Market included endives, coconuts, figs, gooseberries, pomegranates and persimmons—and let's not forget bananas. *Courtesy of Jackie Ferretti.*

How grand? In an era when S&H Green Stamps practically qualified as legal tender, the Ferrettis introduced their own line of redeemable stamps. They were called "Triple F" stamps. Their slogan was "Better Gifts, Fewer Stamps," and I still have a set of *Art Linkletter's Picture Encyclopedia for Boys and Girls*, circa 1961, to prove it.

"They were just ahead of their time in so many ways," said Mary (Ferretti) Hennessey.

> *They all had specific jobs. Before they opened Ferretti's Grill, Aunt Mary worked in the front of the store, my father* [that would be Jim] *did the produce, my Uncle Victor did the groceries and Uncle Arthur put in the meat department.*
>
> *He was really known as a sharp meat man. He'd go to Foster's and Granite State Packing to buy all of his beef, and it's because of him that Ferretti's was known for its fine meats. I'm not sure how happy he was, coming out of Harvard and going to work in the grocery store, but it was family, and it was hard times.*

Towering Titans and Unsung Heroes

They were hard times because Arthur, who had attended Central High School and the Holderness School, graduated from Harvard in 1929. Still, he took to the family business. And what a business it was.

"They used to cater to what they called the 'carriage trade,'" said Mary's sister, Jackie Ferretti.

> *The chauffeurs would drive up, and a clerk from the store would go out to the car and take the order sheet and the driver and the lady of the house would go and shop or do errands on Elm Street.*
>
> *By the time they'd come back, the order would be done and brought out to the car. It was really for the Manchester elite. The Milnes, the Eppleys, the Straws, the Fullers, the Mannings, even Frank P. Carpenter.*

Jackie still has a sample order sheet from the days of the so-called carriage trade, and the array of produce—from the 1930s, mind you—is staggering even by today's standards. Their father proffered pascal celery, endives, finocchio, coconuts, figs, gooseberries, pomegranates, persimmons and eight types of grapes, including hothouse grapes from Belgium at three bucks per pound.

The fruit was always fresh, but the meat was a little special.

"Frank P. Carpenter insisted that Uncle Arthur age his beef for him," Mary shuddered. "He learned how to age the meat until it was green on the outside, and that's just how Frank P. Carpenter wanted it. He'd come in every Saturday with his chauffeur and say, 'That's it. That's perfect. Just the way I want it.'"

Offering fresh meat—even aged meat—became more of a challenge during World War II, but the Ferrettis were up to the challenge.

"I can remember during the really hard times, 1942 and 1943, they bought the Stark Mill and they started raising chickens in there," Mary said. "They had these lights that hung way down from those high ceilings, and that would keep it warm near the floor where the chickens were."

Jackie started laughing. "The big unanticipated factor," she said, "is what would happen when the trains went by. The chickens would get scared, and they'd all stampede into the corners. They lost so many chickens they decided to get into frozen foods. They were the first ones to distribute Birds Eye frozen foods north of Boston."

In time, the Ferretti empire spread north, south and east. In addition to the main grocery store at 1157 Elm Street, they added a southerly location at 589 Elm Street (now site of the Verizon Wireless Arena), and in a revolutionary move, they headed east in 1959, away from downtown, and developed a

sprawling twenty-seven-acre site on Hanover Street near Lake Avenue that is now called East Side Plaza.

The Ferrettis developed the original Sears, Roebuck building on North Elm Street, which featured the first escalator in Manchester ("But it only went up," Mary noted). At one time, the family owned the Chandler Block, the Kearns Building and the Nightingale Building, and the empire included the Hanover House Restaurant, Lord's Department Store and the Radio Cab Company, but it was food—their bread and butter—that made the Ferretti family a Manchester institution.

Joe and Rosa Ferretti taught their kids about the American dream. The four kids lived it. And now they're gone.

February 7, 2003

THE POW PRIEST

Since I always make a sincere effort to practice what I preach, I recently made a donation to the Manchester World War II Memorial Fund. I've already donated time and toil to the project, but I believe it's one of the most important local undertakings in my lifetime, so it's time to do more.

Still, for all of the hard work that has gone into compiling the list of names that will appear on the monument, some of those who served our country in that great conflict may be left out.

The Reverend Luc Miville is one such man. His name may not appear on the monument because when he served our country in World War II, he didn't wear a uniform. He wore a white collar.

Father Luc Miville was a West Sider, the twelfth of sixteen kids born to Marie and Joseph Miville, who made their home at 250 Thornton Street. By the time he was eighteen—at his mother's urging—he became a missionary priest with the Oblates of Mary Immaculate.

Upon his ordination in 1939, due to his fluency in both French and English, he was asked to serve on the staff of Superior General of the Oblates Theodore Laboure. Although Father Luc was based in Rome, he spent a year visiting Oblate missions in far-flung corners of the globe.

Then World War II erupted in full, and decisions had to be made.

"As a French citizen, Father Laboure had to return to France," said Father Luc's nephew, Larry Autotte. "My Uncle Luc was offered immediate passage to the United States, but he asked Father Laboure how long the war might last, and he said, 'Hopefully, not more than a few months.' Based on his assessment, my uncle stayed on his staff, headquartered in Marseilles."

Larry has compiled a detailed chronology of his uncle's wartime experience, and it is reinforced by a lengthy story published in the *Manchester Evening Leader* when the war had ended.

When he visited the Vatican in 1939, Father Luc Miville, OMI, had no idea of the horrors that awaited him in Nazi-occupied France. *Courtesy of Larry Autotte.*

"For two years," the *Leader*'s J. Leo Dery reported, "Father Luc practiced his ministry in Marseilles without being molested. His life changed in November of 1942 when the Germans invaded the unoccupied part of France and took possession of Marseilles…Two days later, the Gestapo agents called at the Mother House for Father Luc."

"I had anticipated that possibility," Father Luc stated. "I started growing a beard four months earlier, assumed the fictitious name of Louis Bernard

and with the help of some friends forged a French passport. Two days after the Nazis had come looking for me, I went to Lyon."

Before long, he was aiding the French resistance from a seminary in La Brosse-Montceaux, about fifty miles southeast of Paris. His language skills enabled the Oblates to set up a shortwave radio network through which they coordinated the nighttime parachuting of arms and munitions into the local farms and fields.

At other times, more than weapons parachuted into their midst.

"They also helped American and British aviators who had to parachute to safety," the *Leader* reported. "From there, they were passed along to underground agents who guided them to safety. Father Luc said that on one occasion, he took a captain—a squadron commander from Los Angeles—to Paris, and two weeks later, the captain was back in England."

Here's how Father Luc told the rest of the story:

> *In July 1944, a chief of the underground in that community was captured and went through unspeakable tortures. He finally disclosed that the ninety Oblates were members of the underground.*
>
> *At five-thirty on the morning of July 24, a detachment of soldiers, headed by a Gestapo chief, arrived at the scholasticate. They lined all ninety of us in the yard and asked questions, but no one answered. Finally, five fathers were taken into the house. They were subjected to inhuman tortures but they refused to talk. They were brought back into the yard where the rest of us stood, and they were shot in front of our very eyes by machine guns.*

The arrival of a German colonel likely prevented the slaughter of the remaining eighty-five priests and seminarians, but it did not prevent them from being transported to a concentration camp at Compiegne, where several more of their number would die.

"It is almost inconceivable the tortures to which the Gestapo subjected the people," Father Luc said. "Tortures such as walking barefoot on hot iron plates. I have seen people who have been whipped with the ox whip and are now blind from blows to the face. I have seen some of our own Fathers whose finger nails and toe nails have been pulled out because they refused to talk."

On August 14, the priests learned that they were to be transported to Buchenwald. The resistance learned of the move and destroyed the train. A second transport was set for August 25.

"This time, the underground learned of it too late," he said, "but they notified the Allied air forces. Allied planes destroyed the rail lines ahead of us, and we traveled barely fifty miles in twelve hours."

The priests and their fellow captives were housed in barns in the village of Perrone, and suddenly, their German captors simply fled.

"It was August 31," Father Luc told the *Leader*.

All this time, American troops were approaching and the Germans abandoned the camp. At dusk that evening, we encountered our first American soldiers. I asked an M.P. where he was from and strange as it seems, he replied he was from Manchester. He told me he lived on North Elm Street but unfortunately, I do not remember his name.

Father Luc's nephew does.

Larry Autotte discovered that the GI from Manchester who greeted his uncle was Private Ferdinand "Fudge" Gosselin—a name he'll never forget—and every year on July 24, the people of La Brosse-Montceaux still remember the sacrifice of the five Oblate priests.

In the end, the U.S. Army did not forget what Father Luc had done in service to his country.

Larry has another news clipping from the *Leader* that states that after his uncle was liberated, he was assigned to "the Ministry of Prisoners and Deported with a captain's rank and pay." So, with the gracious consent of the Manchester World War II Memorial Committee, the name of Father Luc Miville, OMI, will be placed on the World War II memorial after all.

January 26, 2009

THE STARK REALITY

I think I'm getting an inferiority complex.

Yes, granted, I am inferior in many ways, but hey, give the devil his due. In recent years, I have gained some renown as the "Clown Prince" of the Queen City, yet it has finally occurred to me that no matter how hard I try, I'm never going to be Manchester's favorite son.

John Stark beat me to it.

Think about it for a minute. Manchester has a Stark Park, a Stark Street and a Stark Lane. We also have the Stark Mill, which now houses the Stark Mill Brewery, where my beverage of choice is General John Stark Dark.

I can't get away from this guy.

Even his boyhood home is a local landmark. Tourists flock to the Stark House at 2000 Elm Street, but the only people who flock to my boyhood home are my parents, and that's only because they still live there.

Wait. It gets worse.

I recently discovered that my very own personal home, the lavish estate known as Clayton Place, sits on land once owned by the good general. My response to this latest assault on my ego is unimaginable.

It's totally un-Starklike. Yup. I give up.

Certainly that's something that John Stark never did as he forged his way into the history books, but one of the ironies of his notoriety is that so few of us can readily recall the details that made him so special. Sure, we all get a cursory look at his life in the fourth grade when we're dragged kicking and screaming through New Hampshire history, but we seldom hang on to the specifics.

I call it the "Too Close to Home Syndrome." And what is this syndrome? It's the reason people from New York City visit the White Mountains without ever seeing the Statue of Liberty. It's the reason people from Washington,

D.C., visit the Statue of Liberty without ever seeing the Washington Monument. And it's the reason people from New Hampshire visit the Washington Monument without ever seeing Mount Washington.

It just seems like the local is devalued simply because it's local, and all of my petty jealousies aside, John Stark deserves better. As proof, I have an amateur historian's rule of thumb. For me, the true measure of a folk hero comes when you try to separate the man from the myth. In the case of John Stark, a myth is as good as a mile of documentation.

Let's consider his capture by Abenaki Indians while on a trapping and mapping expedition about 1752. Legend has it that young Stark was forced by his captors to run the gauntlet, and it is here that accounts vary. According to some, Stark rushed the line, grabbed a club from the closest brave and slugged his way through. Others, like author Grace Holbrook Blood, say that Stark began his run by proclaiming, "I'll kiss all your women," which set the braves to laughing so hard that he finished his run unscathed. Personally, I prefer the image of the colonial Lothario.

That may be wishful thinking on my part though. The truth is that the guy wasn't what you'd call a million laughs. Even his most giddy biographers describe him as "dour" and "taciturn." I could only find evidence of one wisecrack. When he was ultimately freed by the Indians for a ransom equal to $103, Stark said it was the only time in his life that he knew what he was worth.

If he wasn't Rodney Dangerfield, however, he was no stranger to danger. When duty called, Stark answered. The first call came in 1754, so he parlayed his experience with the Indians into a commission with Rogers' Rangers and fought on the side of the British during the French and Indian Wars.

When the French eventually capitulated, Stark returned home to raise his family and carve a living out of the hard land around Amoskeag Falls. In his day, though, the call to arms was constant, and by 1775, goings-on at Lexington and Concord forced him to abandon Molly and his lumber mill yet again.

Two months later, as colonel of the First New Hampshire Regiment, he was staring down the barrels of British flintlocks at Breed's Hill in Boston. It was there where Stark's men—outgunned and outmanned—managed to repulse two British attacks, and even though they withdrew before a third assault, his men had shattered the myth of British invincibility at the Battle of Bunker Hill.

To this day, historians admire his bitter refusal to let the British pass, but that didn't prevent colonial leaders from passing him over for promotion. Part of the problem was that Stark didn't suffer fools gladly. He had little

The stark truth of the matter is that no one from Manchester can come close to matching the historical legacy of General John Stark. *Courtesy of Manchester Historic Association.*

use for and even less patience with insufferable superiors and preening peers (who does?), and he didn't mind letting people know. In that way, Stark was a lot like another general of note, one George S. Patton. He was a soldier, not a diplomat, and when his candor led the "nincompoops" in the legislature to choose a lesser light to lead the New Hampshire troops, he trooped back home to Manchester.

Fortunately, his indignant retirement lasted a mere four months. When colonial forces were routed at Fort Ticonderoga, Stark was belatedly named brigadier general of the New Hampshire troops. In no time, he was heading off toward Bennington, Vermont, for another rendezvous with history.

What transpired there on August 16, 1777, helped shape the fortunes of a nation, as Stark outfoxed Gentleman Johnny Burgoyne, bested the Hessian hordes of Colonel Friedrich Baum and thwarted British efforts to split the colonies in half geographically. Soon thereafter, the depleted British forces were beaten at Saratoga, and the quaint notion known as the United States of America became a reality.

Am I exaggerating? Am I being a homer? In spite of my own personal jealousy, am I gilding the lily of history to make John Stark look good? Here's an impartial opinion issued in 1904 by New York historian Dr. William O. Stillman on the Battle of Bennington:

> *The battle on the Walloomsac* [River] *was undoubtedly the turning point of the British success in America. It made possible the great victory at Saratoga which determined the destiny of a continent, and is ranked, along with Marathon and Hastings, as one of the fifteen great battles in the history of the world.*

So why has all this come up today? Well, the anniversary of Stark's birth is August 28, and I can't think of a better time to reflect on the achievements of the man who will always be Manchester's favorite son.

And that's the stark, naked truth.

Whether I like it or not.

August 25, 1997

ABOUT THE AUTHOR

John Clayton is a native of Manchester, New Hampshire. For the past twenty-five years, he has been a feature columnist for the *New Hampshire Union Leader*. In addition to numerous awards for sports writing, feature writing and investigative reporting, he has been honored three times by the New England Associated Press with Best Local Column honors, and he also received an Emmy award for his work with New Hampshire Public Television, where he served as host of *New Hampshire Crossroads*.

For his many stories on behalf of veterans, the Catholic War Veterans of America presented him with its 2008 National Media Americanism Award. In addition, the man who was described as the state's "leading culture maven" by *New Hampshire* magazine has also written six other books about Manchester and New Hampshire, including *You Know You're in New Hampshire When...*

His website is www.johnclayton.info.

Also by the Author

In the City
Faces and Places In the City
Stark Realities In the City
New Hampshire: The Way I See It…
New Hampshire: War and Peace
You Know You're in New Hampshire When…

Please visit us at
www.historypress.net